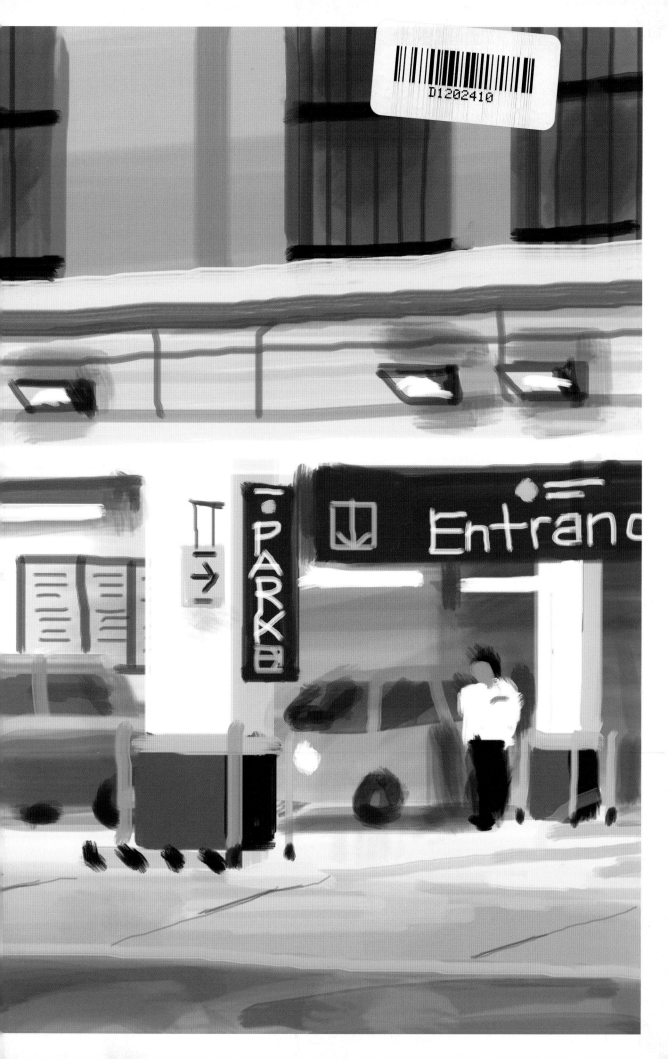

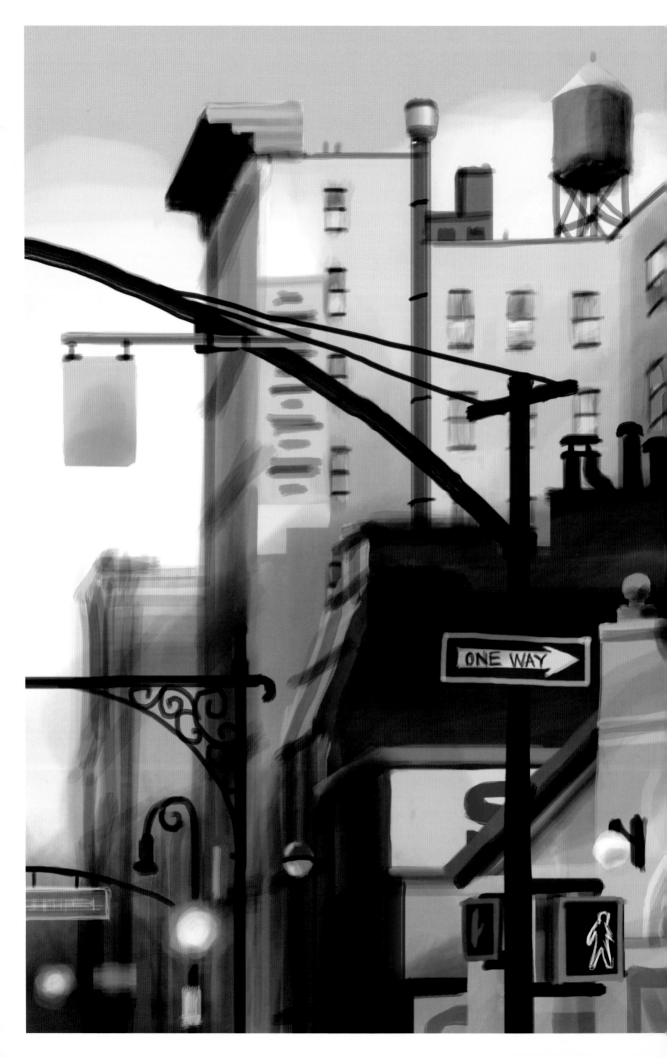

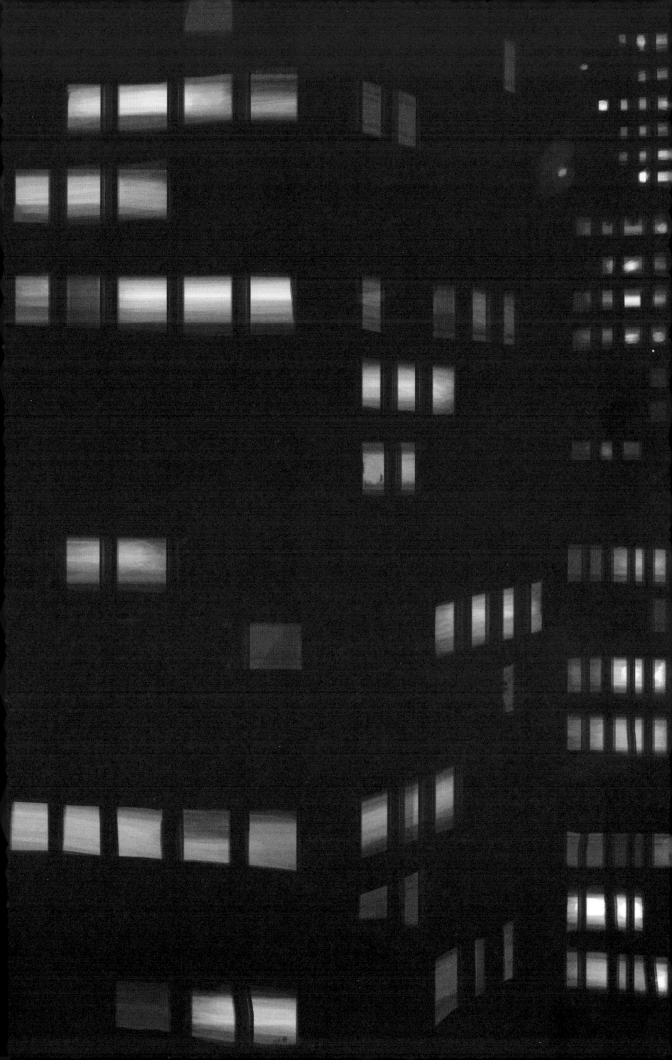

NEW YORK

FINGER PAINTINGS BY
JORGE COLOMBO

with essays by Jen Bekman
and Christoph Niemann

jorge colombo

CHRONICLE BOOKS
SAN FRANCISCO

PUBLISHED
IN ASSOCIATION WITH
20X200.COM

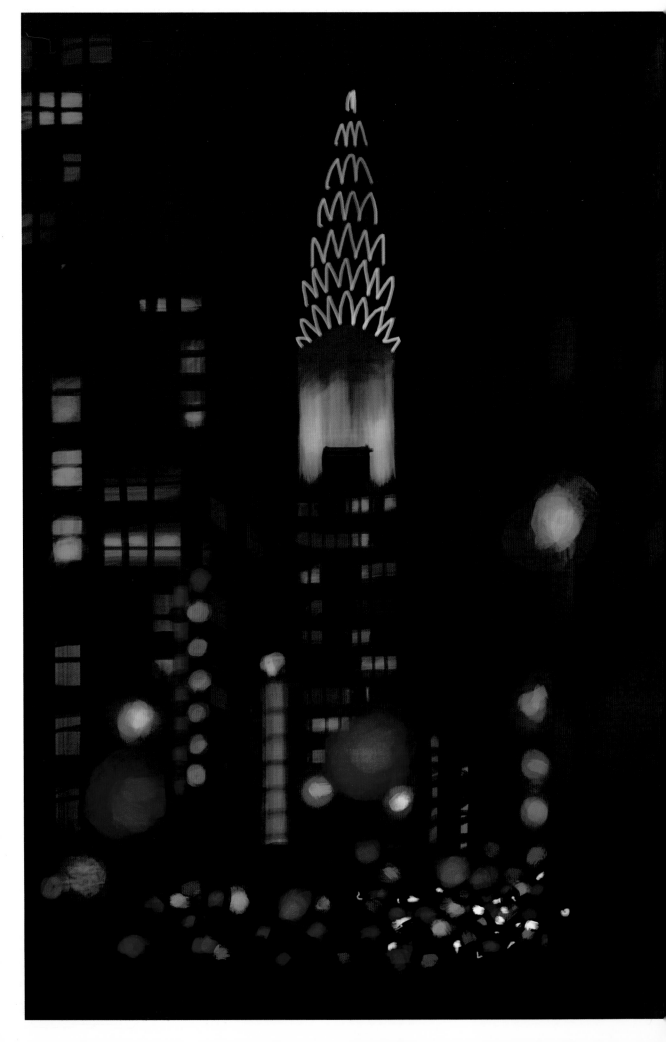

INVISIBLE CITY BY CHRISTOPH NIEMANN

MY FAVORITE DRAWING IN THIS BOOK IS THE NIGHT VIEW OF THE CHRYSLER Building viewed from Lexington Avenue. It's not Jorge's drawing though—it belongs to me.

The chaotic and blurry mix of car and traffic lights. The patterns of night-lit office windows. The Chrysler Building, hovering above the scene like an aristocratic spaceship. I have carried that image in my head for years.

Actually, before I saw this drawing it was not one image, it was a hundred images. I have looked at this street scene countless times: getting out from the airport shuttle at Grand Central, all dizzy and jet lagged on my first trip to New York, racing to catch a Metro North train on a Friday night for a trip upstate, or walking back from a midtown dinner, late at night, fighting for a cab and usually ending up taking the subway after all. There must be millions of photos of this very view, but each of them can only represent a single facet. Jorge, on the other hand, has taken this whole pile of my accumulated mental snapshots and melted them into a single piece of art.

Like many illustrators, I constantly scout life in New York for new and unusual facets, trying to connect to the reader through high-strung irony and multi-layered references. Jorge reminds me that there is a much straighter path to the viewer's mind: he wanders around town and visually records everything he sees. He devotes an even artistic love to everything he sees, whether it is a majestic skyscraper or a run-down highway bridge.

When you spend years living in a city, there comes the moment when it becomes so familiar that it almost appears invisible. Jorge seemingly just puts his focus on the surface of things, filters it through his eyes and hands, and thus helps me re-appreciate the city.

In art school, they teach you to always keep a sketchbook, and I sometimes regret not spending more time to record my very subjective impressions of New York. Looking at Jorge's drawings, however, it is a relief to see that somebody else can actually do that for me.

HOME TURF BY JEN BEKMAN

EVEN BEFORE I'D SEEN HIS WORK, JORGE AND I WERE friendly for years. I had the pleasure of chatting with him at cocktail parties and openings at my gallery—these encounters were later supplemented with a steady stream of online banter that kept (and continues to keep) me apprised of his constant creative output. As our friendship evolved, I paid keener attention to those updates, but it was a post on the venerable Design Observer's website that tipped me off to the iSketches that are the subject of this book. Immediately intrigued by work that unified two of my abiding passions—NYC and technology—I was thrilled to discover that my mustachioed friend had created it, and thrilled again when he quickly agreed to work with us at 20x200 to publish physical prints of his heretofore-virtual works.

Like those prints, the drawings you see on the pages that follow are the result of Jorge's lifelong dedication to being an artist, both in training and trade. A master in multiple mediums, Jorge has made a seamless transition from notebook sketches, illustrations, and paintings, to iPhone drawings. He was among the very first to adopt this most modern of media — the touch screen of his iPhone and a popular app called Brushes.

As he wrote in the original statement that accompanied his prints on 20x200, they're "drawn on location using an iPhone application called Brushes. No photo references, no tablets, no brushes to wash: just my finger on the tiny touch screen. Don't even need a proper light: the drawing itself glows in a dark corner." Translated from screen to print, these little masterpieces are wonderful. The first time I saw the physical proof prints of them, I was amazed and giddy for days.

The iPhone has allowed Jorge to bring the digital milieu he's so familiar with out into the world with him, transforming it into his studio. But, when he's drawing in this medium, he looks like any other modern-day city-dweller distractedly attending to elsewhere as the city makes its way around him. Jorge tells me he gets a kick out of that: people think he's sending a text message or responding to an e-mail, when what he's really doing is committing a time and place to memory. I know he loves how stealthy his method is, a far cry from the conspicuous creativity of the plein-air painter's easel and palette. In fact, it's even less noticeable than sketching in a Moleskine, something else he's done plenty of. Jorge is always on the prowl for interesting venues to draw from—he's happy to stand or sit quietly in the corner

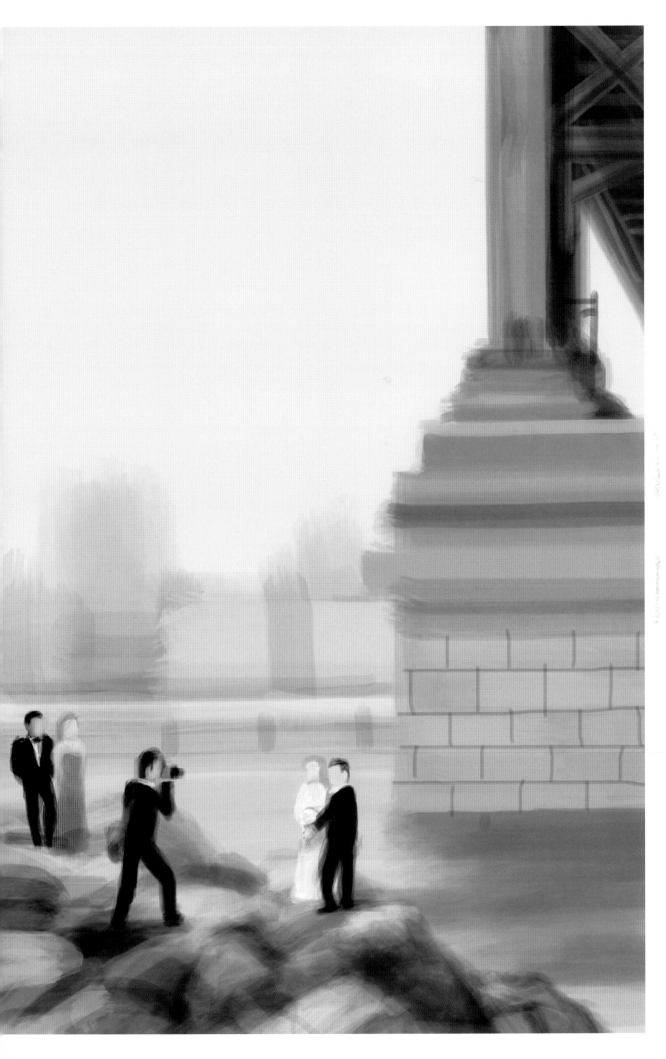

of a friend's office for hours at a time if it allows him to see the city from a new perspective.

When this very book was just a glimmer, Jorge and I met for lunch at Café Gitane in Soho. We discussed the project, which in turn became a talk about all the other books we love. We're both serious bibliophiles with a reverence for print, so the conversation stretched on and on. After eating, we walked over to the nearby bookstore McNally Jackson and looked at books, and then the magazines. From there, our talk moved towards cinematic depictions of New York City as seen in *Taxi Driver*, or the brilliant single-shot chase scene in *The French Connection*. And then, as though saving it for that very conversation, Jorge took his phone out of his pocket to play me the opening credits of Woody Allen's *Manhattan*. It's a sequence that I'm very familiar with, and one that has partially overtaken my psyche, becoming a part of my memory as experience rather than cinema. That Jorge carries this around with him is telling, about his devotion to this city, and about how powerfully it has influenced him.

EVERYONE HAS AN IDEA OF WHAT NEW YORK IS, OR at least thinks they do, shaped by movies, books, photos. It's such a legendary setting that millions (billions) of people who've never been here in person—even those who might be otherwise unconfident—think they know exactly what it's like. It's as though the city's essence exists as common property of the world's imagination.

Having grown up here, the idea of an unknown New York is unimaginable to me and of the idea of moving here, as Jorge did, is that too, and also, brave. I'm a little jealous of anyone who gets to have clear memories of their very first New York City moments. Everybody who came here from somewhere else has a story about the first time they saw the city: coming in on an airplane or approaching the island of Manhattan via the BQE. I don't have a first memory—I've always been here. It's always been home. For newcomers, there is life before New York and then life in New York. As a native, I envy people who cultivate new memories as the city of their imaginations refracts through the lens of their new experiences. While I'm thrilled and proud that living here continues to excite me every day, that before and after is something I've never

had—the city has never been a place that lived solely in my imagination; it's essence has been my reality from the very beginning.

That doesn't mean, though, that some parts of my personal version of New York City haven't been shaped by others, as Jorge's idea of New York was influenced by the opening credits from *Manhattan*. The New York of my childhood maps to the imagery in Ezra Jack Keats's children's book *The Snowy Day*. Today, as an adult, it is Jorge's sketches, of Grand Central Station and the exterior of the famous Katz's Delicatessen at night, that capture New York in a way that evokes my experiences and memories of the city. Jorge depicts these places with broad strokes and imprecisely shining lights, creating the impression that everything is moving—the traffic and the people, each one of us contributing to the shimmering shuffle of the city's pulse. This is the feel of the New York I know.

The iconic New York of now-classic films is what drew Jorge here to begin with, and now he finds himself as those auteur heroes of his used to be—his drawings pull from the energy and inspiration of the real city that he has immersed himself in. I can easily imagine him as an island in the stream of New Yorkers and tourists, sketching on his phone at some of the busiest intersections of the world.

One of the things I love about traveling is that the feeling of being a tourist remains with me for quite a while after returning home—it's the closest thing to that new New York experience. Accustomed to being disoriented, I don't quite snap back into habit right away. Instead, I find myself looking up and around, scanning the skyline and plotting my paths more deliberately. It always makes me fall in love with the city a little more.

Cutting through Cooper Square one evening not so long ago, having just returned from a trip abroad, I looked up to see the Empire State Building aglow in the earliest-of-evening light. Noticing it then, it became fixed in my mind. I imagine that it'll stay there for a while, reminding me of feeling at home and in love with where home is. If you were to ask me to describe that image, I'd tell you that the picture dwelling there is no perfect snapshot. There's no way I could explain it in words or draw it myself, but I can tell you with absolute certainty that it looks a lot like one of Jorge's sketches.

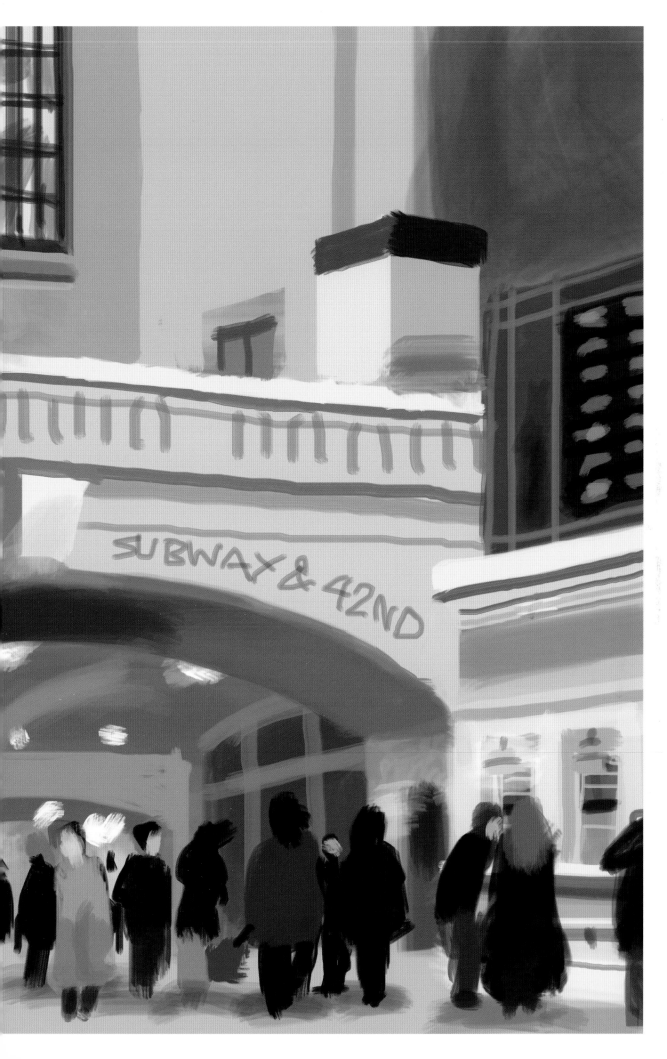

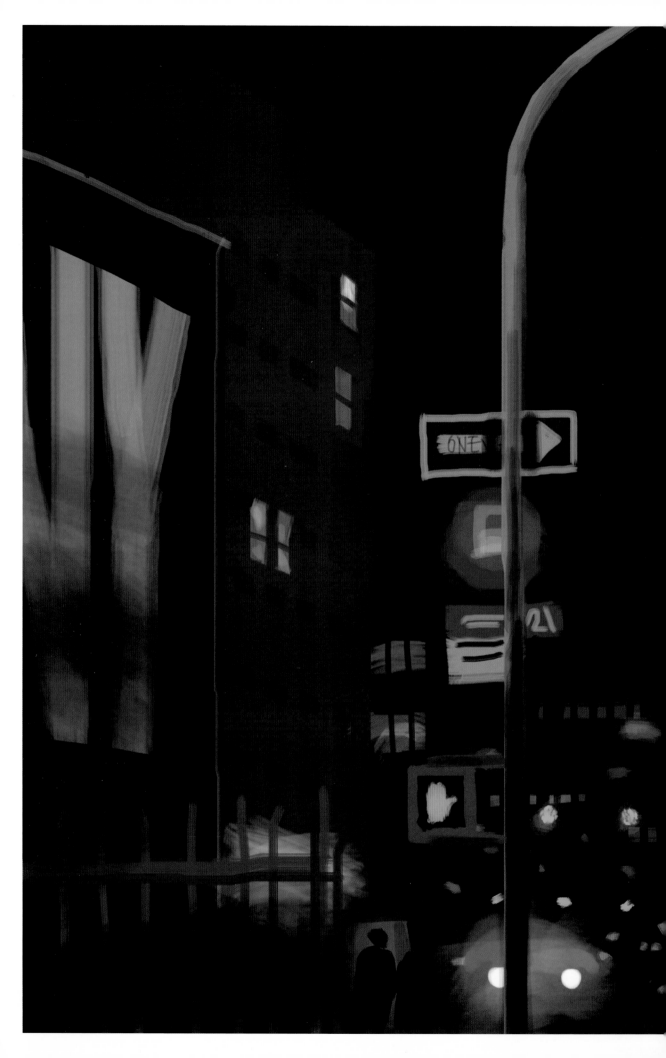

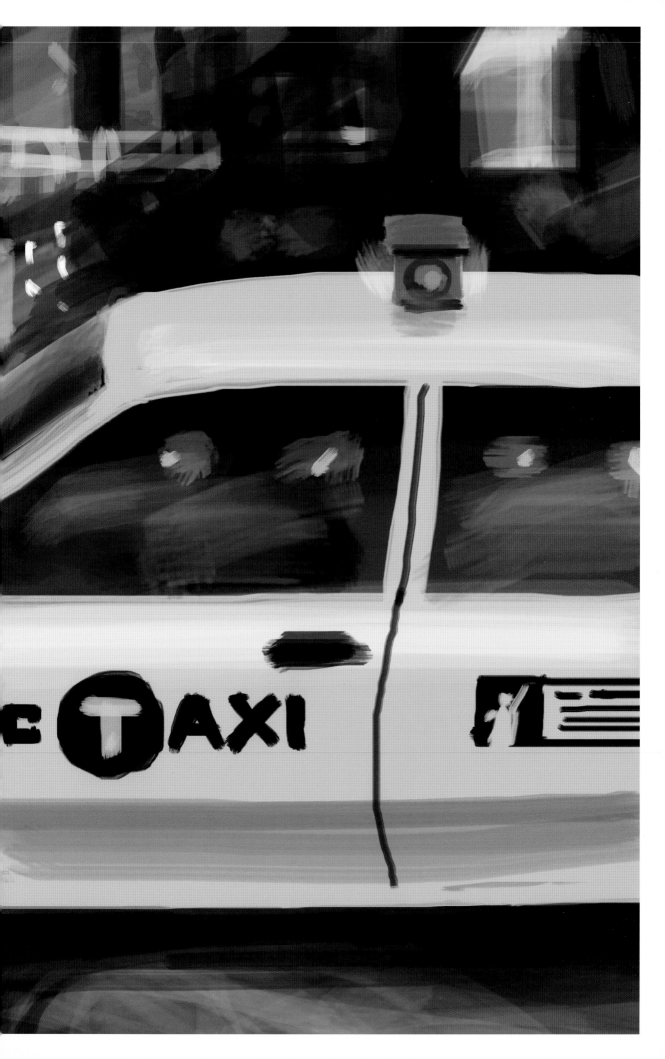

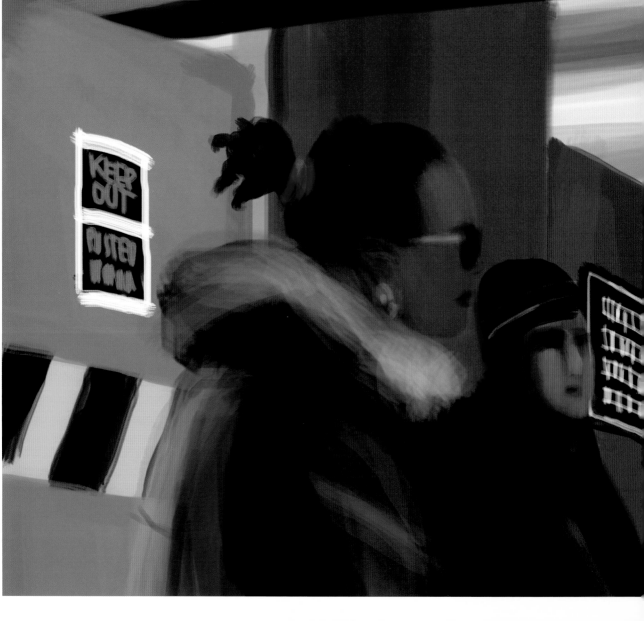

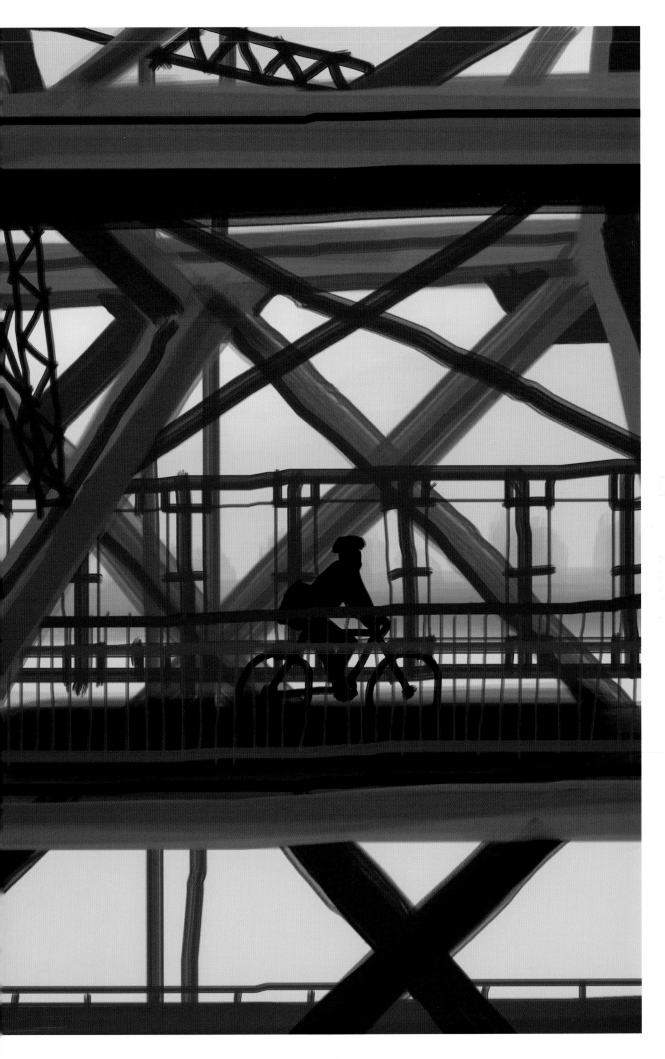

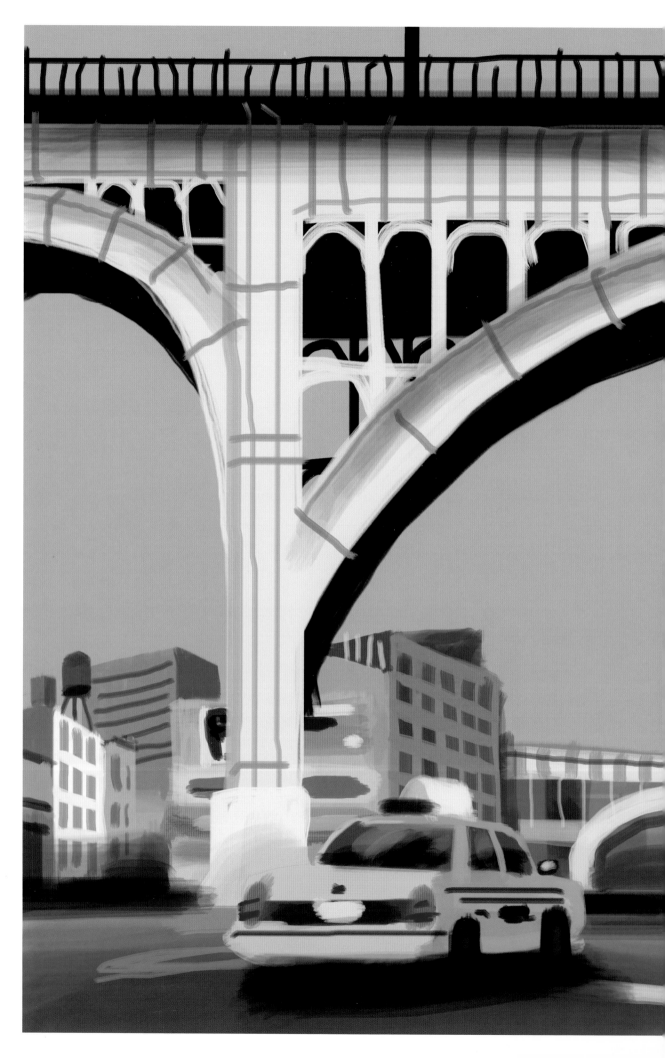

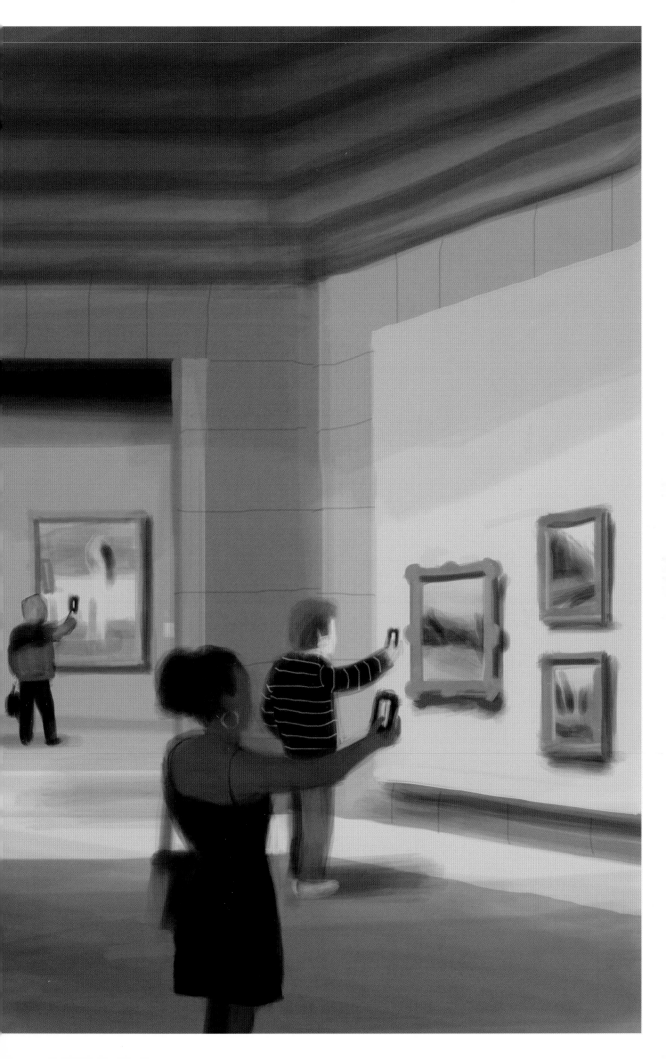

FIELD WORK BY JORGE COLOMBO

EACH IMAGE IN THIS BOOK WAS PAINTED FROM LIFE,
on location in New York City, between 2009 and 2010.
And each image in this book was finger painted on
an Apple iPhone G3, using an application called
Brushes 1.1. (Both my hardware and software were
already outdated at the time of this writing, by the
way.) No photos or sketches of any kind were used.

It might have been easier to work from photo-
graphs: a snapshot takes only a moment, and then
you bring it to your desk and take your time. But I
prefer an image to carry my memory of the hour or
two I spend standing on a sidewalk, drawing from
the urban life passing by.

Cities end up acquiring their visual personality
by way of collective contributions. Hard as they are to
trace back to their origins, there are factors that define
prevalent styles of windows or a main palette for
buildings. Sometimes the identity of a city is obvious—
details and landmarks easy to spot—but often that
identity is to be found in subliminal touches. I find it
a richer challenge to extract the intrinsic New York–
ness or the San Francisco–ness out of a nondescript
vista. That essence can be in the proportion of the
sidewalks, scale of the buildings, quirks of architec-
ture, urban vegetation, or quality of light. Like the
chords of a tune that brand it as Cantonese, like
a group of tourists that somehow projects "Scandi-
navian," something triggers identification.

I grew up in Lisbon, Portugal, and moved to
the United States in 1989, at the age of twenty-six.
I've been fascinated by the visual patchwork of the
cities I have lived in (Chicago, San Francisco, New
York). I look for the traces, the scars, the accidents
that have changed the character of a building or a
street over the years. Architecture and urbanism's
grander designs are fascinating, but so are the
instinctive interventions of mere users, clumsy and
misguided as they may be. There's as much humanity
in dysfunction as in sophistication. Every detail,
accretion, modification, damage, or patch speaks
of the people who at some point passed through
the landscape. I like to imagine their stories.

In my early New York years, I drew pen-and-
watercolor portraits of passersby glimpsed in the
street, one a day. I called that project *The Dailies*.
Rather than choosing eccentric characters, I favored
those I felt I had seen twenty times before. No par-
ticular emphasis on likenesses either, but I made
sure each clothing detail was correctly recorded.
The shape of a nose is just an accident of nature.
The length of a dress, the brand of a shoe, a tattoo,
these are cultural choices, more often than not
insights into one's self-perception, heritage, or aspi-
rations. Crowds tend to sort themselves into style
subgroups, not as many as we would imagine. Cer-
tain clothing items or hairstyles are almost exclu-

sive to specific age, ethnic or social groups. This will to conform to the sameness of a group sounds boring and unimaginative; to me, it's also touching. People are trying to belong somewhere.

A TECHNOLOGICAL BREAKTHROUGH TENDS TO BE exciting at the beginning, and then it's just a footnote. Doing something early on isn't as relevant as doing something that will live on. We don't really care about who first used acrylic paints or camcorders. The same phenomenon will happen with the iPhone, the iPad, and whatever follows. Just one more tool. And it won't eliminate the tools that preceded it, either: acoustic guitars didn't die when electric ones came along. Our tool kit is simply expanded. Using black and white film in 1910 was the only possibility; today, it is a choice, and thus has a different meaning.

Until the iPhone/iPad touch-screen boom, painting digitally was for the most part an indoor affair. On a park bench, even a laptop felt clumsy, let alone one with a drawing tablet connected to it. The iPhone/Brushes combo turned out to be to digital painting what 35mm film and Leica cameras were to early photography. Lugging a high-end, large-format apparatus to a location is still an alternative, but the allure of pocket-sized equipment is hard to beat. Computer touch screens seem like an inevitable development, both as a future standard and as a common art-making tool. To me, everything else—keyboard, mouse, tablet, stylus—feels obtrusive by comparison, like a prosthetic.

There are other apps around, but Brushes, created by Steve Sprang, a former developer at Apple, has served me well, so that is all I've used so far. Although Sprang has continued to improve the software, for a long time I chose not to upgrade, and stuck to one of the earliest versions: only three brush types and no layers. (Layers are a major perk in graphic programs. Like multitrack music recording, they allow you to work each component individually without affecting the others. But I enjoy the risk factor of having to get it right on the first pass.) The learning curve wasn't that steep. It took me a while to confine myself to the 2" x 3" screen, but zooming in (800% maximum) and out (70% minimum) quickly became second nature. In fact, I have always tended to draw small, so covering the length

of the canvas with a simple finger motion allows for broad strokes and easy control of composition. The brush width can be calibrated to a pixel-wide line, so it doesn't matter how thick or slender one's fingers are (a common question). Being able to draw on a surface lit from within makes it at last feasible to work outdoors at night without having to point a flashlight at what I am doing. And since Brushes exports its iPhone files to a regular computer not as images but as scripts, the drawings can be rebuilt as printable high-resolutions—or strung as ever-popular stroke-by-stroke videos. Of course, the videos retain only the correct brushstrokes: mistakes are omitted, which would make any artist come across as preternaturally precise. The speed of those videos is a lie. Half of the process is trial and error.

Artists were working on iPhones long before I even bought one, sharing their work online. (Even one of my personal heroes, David Hockney, has been working on touch-screen devices.) I first discovered Brushes on Flickr, through the sunset paintings of Stéphane Kardos, a French artist living in LA. When I got my iPhone in February 2009, it was mostly to check my e-mail on the go. Soon, I started experimenting with NYC landscapes, and a few of these drawings went up on my Web site. My brother-in-law, Mark Yoes, sent the link to his friend Jessica Helfand, who posted a brief note on designobserver.com. Some media took notice— they can't resist a gadget story—and so did Jen Bekman, a gallerist I knew via mutual friends, who proposed to edition and sell some of my images online at 20x200.com. Those images caught the attention of Françoise Mouly, art editor at *The New Yorker.* She was intrigued by the on-location character of the images. I visited her at the magazine offices, where we looked at every single Arthur Getz cover in the archives. On June 1, 2009, one of my images appeared on the cover of *The New Yorker.* It was the first time a magazine ran a cover entirely created on a cell phone. Other covers ensued; additional images started appearing weekly on the magazine's Web site.

***THE NEW YORKER* COVERS ARE A TIME CAPSULE. AND** reviewing them in sequence is like reading a visual record of the New York intelligentsia's self-image.

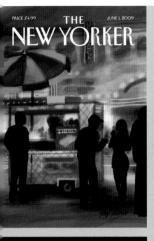
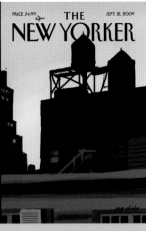
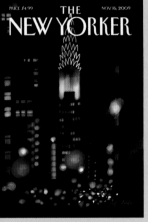
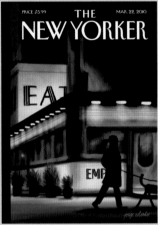

The June 1, 2009, cover of *The New Yorker* fit within the magazine's tradition yet was the first publication cover ever drawn on a smartphone. Other covers, drawn from a steady practice of painting New York landscapes, have ensued.

Other than a decrease in trim size, typographic tweaks, and a big leap from the original 15¢ price, the only way to distinguish this month's cover from one from the '20s is by the clothing styles—or the graphic ones. The sequence of images is riveting. Social classes literally emerge and vanish before our eyes, conventions of dress and posture are revised, the yearly calendar of rituals is revamped. Comparisons are made easier by the consistency of the format. Once-standard service icons such as dignified butlers and drivers become scarce; so do early instances of ethnic insensitivity. The very body types shift. The cocktail shaker-shaped upscale ladies of Helen Hokinson's '30s would be harder to find today: their social equivalents are likelier to be toned by yoga and personal trainers. Authority figures, growing younger and much less portly, are progressively enthralled by technological fetishism. There are only fifty-two weeks in a year, so cover themes are likely to repeat themselves under the Rea Irvin logo; and as decades roll by, that's part of the appeal. Like jazz standards, a cover subject accumulates the patina of a classic as it is reworked by a succession of artists. The predictable calendar occasions—New Year's Day, Thanksgiving, April 15, return to school—are starting points for an intergenerational dialogue between New Yorker artists.

Except for otherworldly eccentrics like Thurber, Addams, and Steinberg, who created their own universes from scratch, the magazine's long-term artists such as Alajalov, Steig, Irvin, and Price remained faithful to New York iconography and its landscape. The first Christmas gift my wife, Amy, gave me was the Knopf album of all *The New Yorker* covers 1925–1989, with an introduction by John Updike. For a newcomer to the country, it was like happening onto a family album. One feels like every neighborhood, landmark, angle, mood, and experience has at some point been depicted there.

THE PAINTINGS I CREATE ON THE IPHONE LOOK UNLIKE anything I have previously done. Although in recent years I had probably worked more on photography than on drawing, and had even started experimenting with short films, most of my career had been as an editorial illustrator. I didn't have a fine arts background of any sort: my preferences ran to commercial

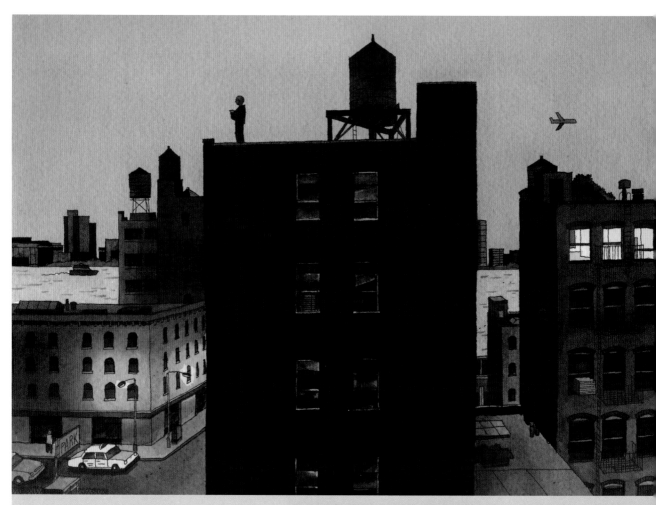

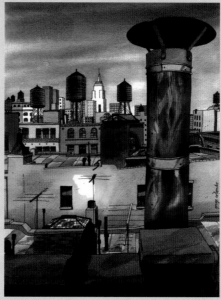

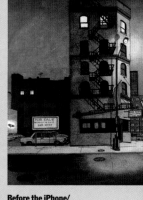

Before the iPhone/Brushes era, a Jorge Colombo drawing would be a meticulous ink-and-watercolor job, with every landscape detail rendered as precisely as possible.

The Dailies was a project featuring passersby spotted in New York city streets, one a day. They were quickly sketched on the spot; watercolor postcard-sized portraits were created later on.

and editorial art. Even my favorite painters, like Edward Hopper and David Hockney, tended to be of the narrative type. Other references for my work were photography (especially pilgrim-like wanderers of the WPA crowd and Robert Frank and Raymond Depardon) and film (cinematographers such as Gordon Willis and Robby Müller) and the meticulous, documentary Japanese woodcuts of artists like Hiroshige. Plus The New Yorker cover artists, who have always struck an ideal balance between commercial art and personal vision.

My drawing technique was shaped mostly by graphic novels of Francophile origin: the Hergé school and, later on, the sophisticated work of the (Á Suivre) magazine authors such as Jacques Tardi and Jacques de Loustal. Everything I did was rooted in neat line work, achieved by successively tracing over my own sketches until they became precise enough, and then applying flat watercolor coats (or, more recently, digital layers).This drawing style is hard to replicate on the iPhone, which feels a lot like painting with a blunt brush. But I have always enjoyed tailoring my approach to imposed limitations. On the iPhone, my line work became tentative, so I abandoned it entirely and concentrated on colors and shadows. I had previously rarely created images with no outlines, but sharp line work and controlled coloring are not easy when you're painting with your finger on a surface smaller than a credit card. Loose smudges and bright layered colors are naturals. So I embraced the language suggested by the equipment, and ended up with a collection of loose, fuzzy, casually brushstroked images that years ago I wouldn't have imagined myself doing. I captured my New York with much more immediacy than I had in my old watercolors.

My first personal interaction with The New Yorker had taken place in 1994. Françoise Mouly had seen some of the watercolor landscapes I was doing in Chicago, and asked me to send her some cover proposals. I had been admiring her choice of artists, many of them European types I had followed since my early years. But those were the Tina Brown years, which were characterized by a return to the more timely, topical newsiness and irony of the Harold Ross '20s. I felt my un-ironic valentines to New York, as I see my images, were out of place in The New Yorker's contemporary universe: I hardly offer a catch, a twist, a comment. My work is about perspectives, volumes, light, details, and atmospheres. I came to believe I had approached The New Yorker a few decades too late.

Yet a steady New York physiognomy has continued to turn up on New Yorker covers between provocative images, well into the David Remnick years. That vision has persisted, as can be confirmed by exploring the long hallways of the Condé Nast Building's twentieth floor, where all the Mouly-assigned covers—around nine hundred of them, by last count—remain pinned in sequence. The recipe for a New Yorker cover is elusive. One key factor does emerge: a passion for and enchantment with the magic of New York City.

THE BEST WAY FOR ME TO FIND PAINTING LOCATIONS is on foot. Sometimes I pick a spot in advance; other times, I simply take a bus or a subway, exit at a random stop, and start exploring. I occasionally do advance research on Google Street View, but nothing replaces location scouting. I often get to a place that I expected to be a perfect subject only to discover that the surroundings are overpowering, proportions are dull, details are off . . . or that the perfect vantage point is in the middle of the street, amid the traffic, which is a problem if you plan to spend any time painting on site. Many of the images in this book are accidents of my everyday errands or recordings of key places from my personal history, memories to keep. A few are responses to other works of art: photos or paintings, film locations, that sort of stuff. It's impossible to capture every aspect of New York City in a hundred images, so this is a personal collection of whereabouts, discoveries, preferences, moments.

Elements clash in an ever-inspiring kaleidoscope. I do my best to keep discovering my surroundings as freshly as if I had just arrived. The deep accumulation of historical resonance, ambitious development, art iconography, pop culture references, architectural landmarks, loads every New York street with its own lore. As often happens, ditching my precedents and changing my approach altogether when I started using the iPhone turned out to get me closer to my deepest intentions. These were the images I wanted to get out of New York all the time.

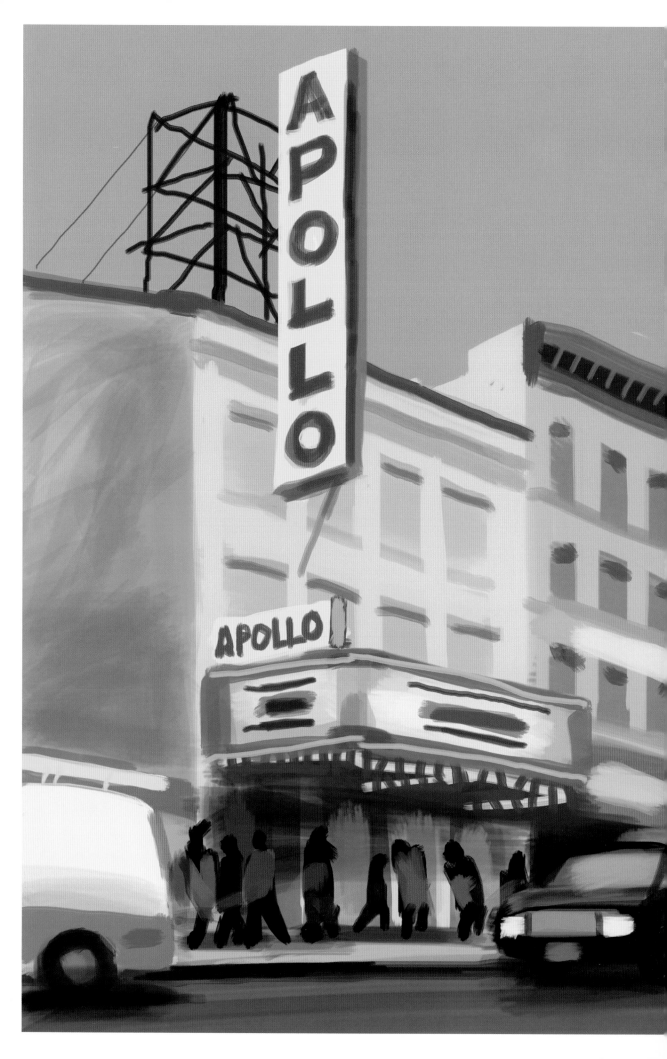

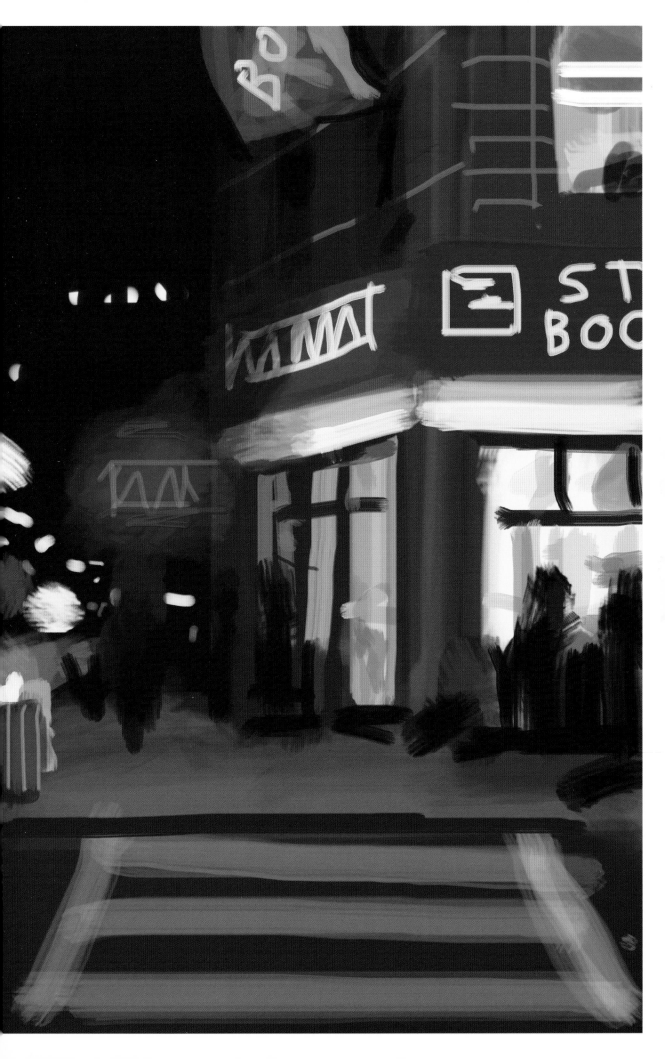

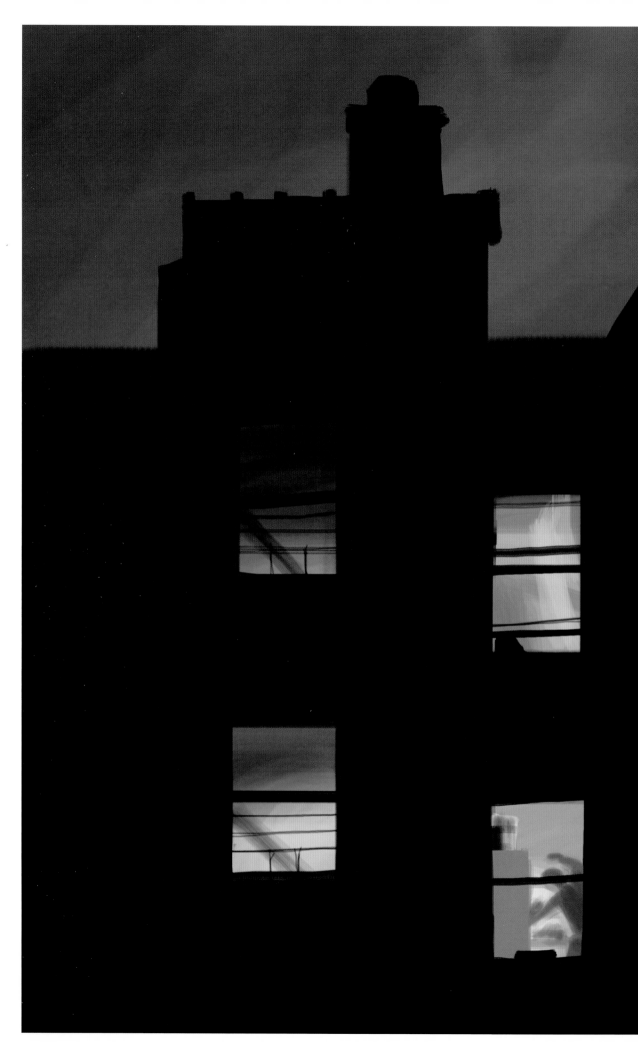

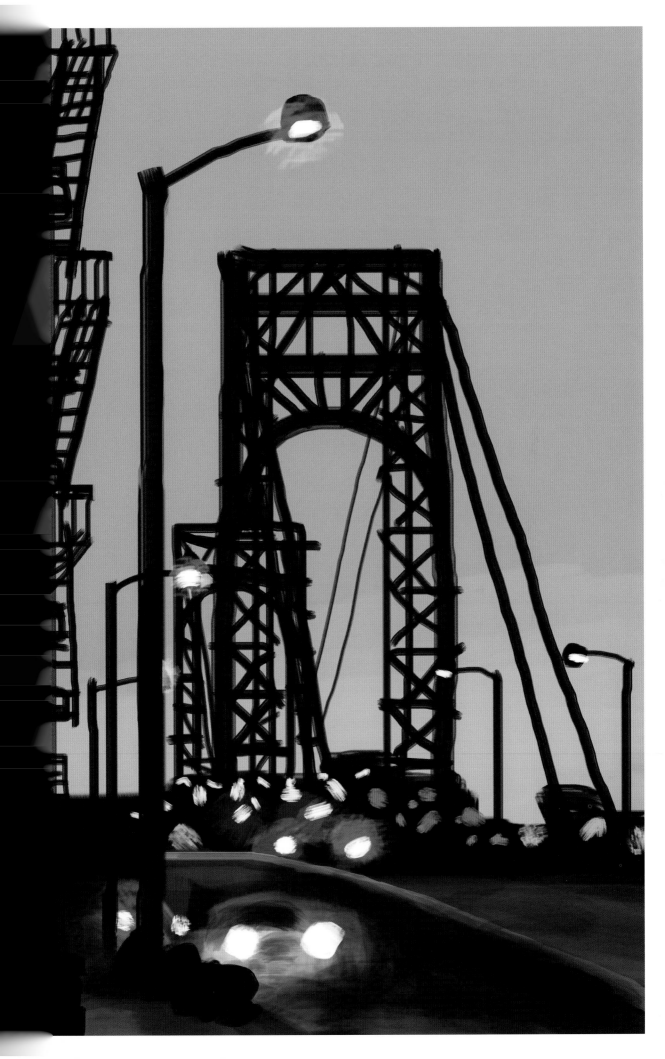

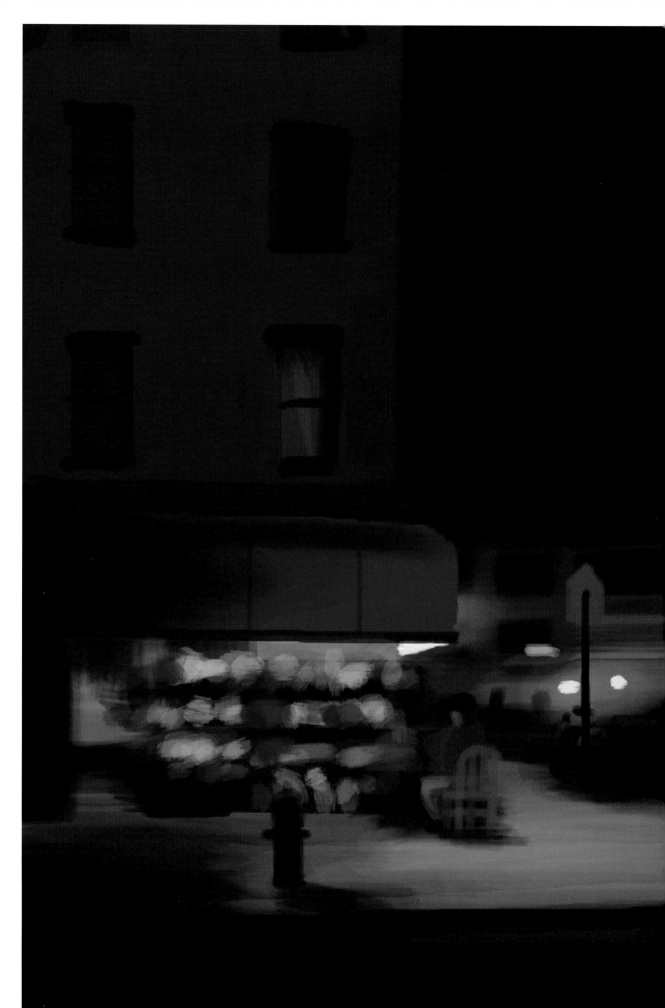

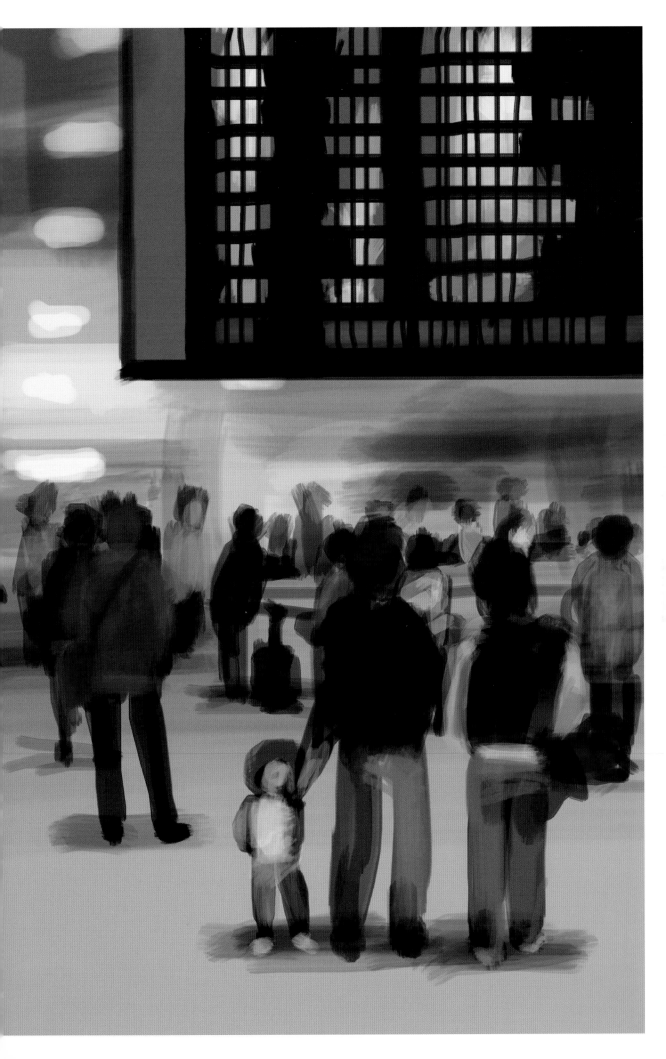

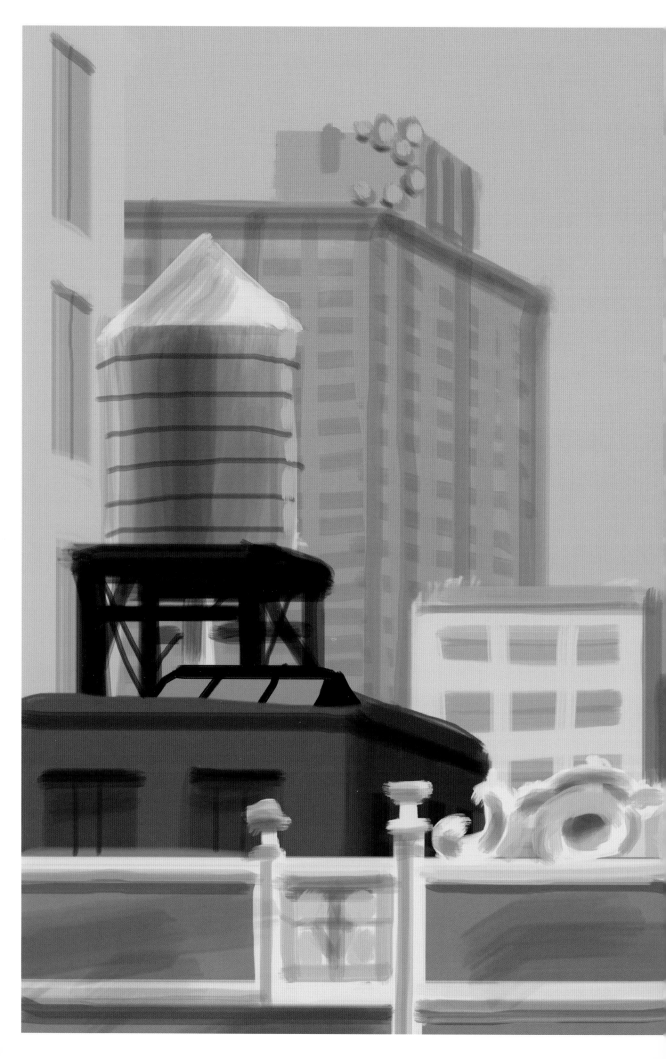

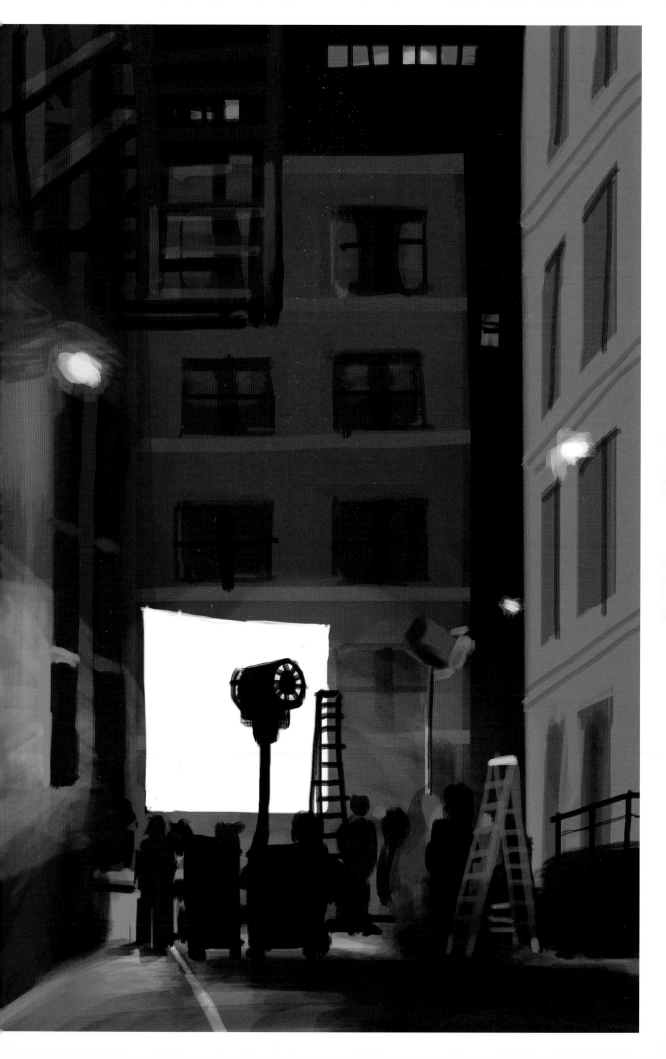

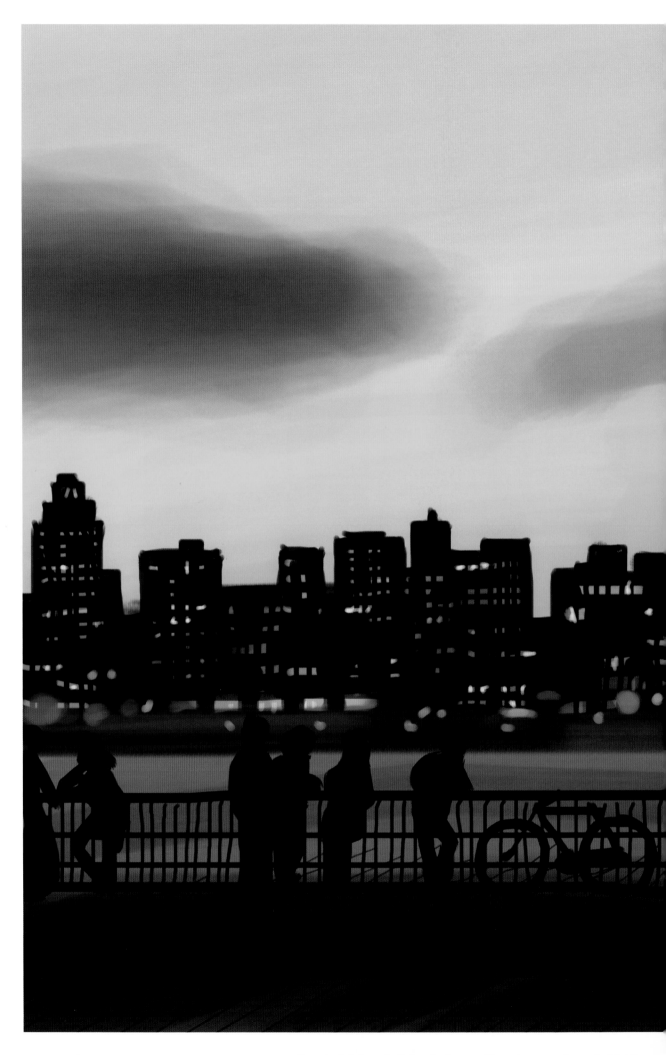

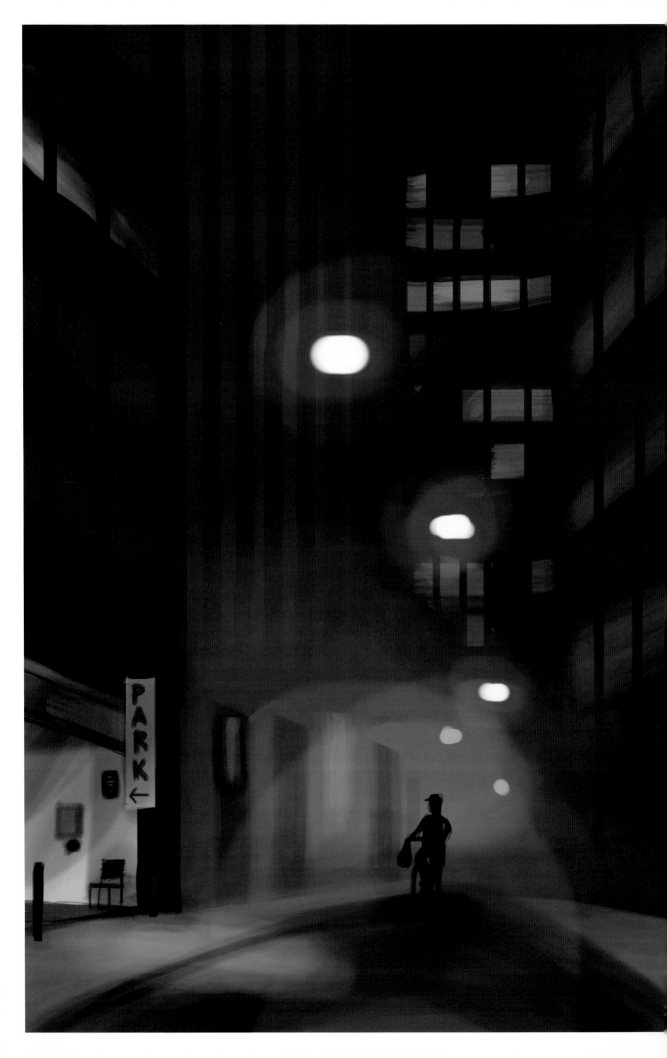

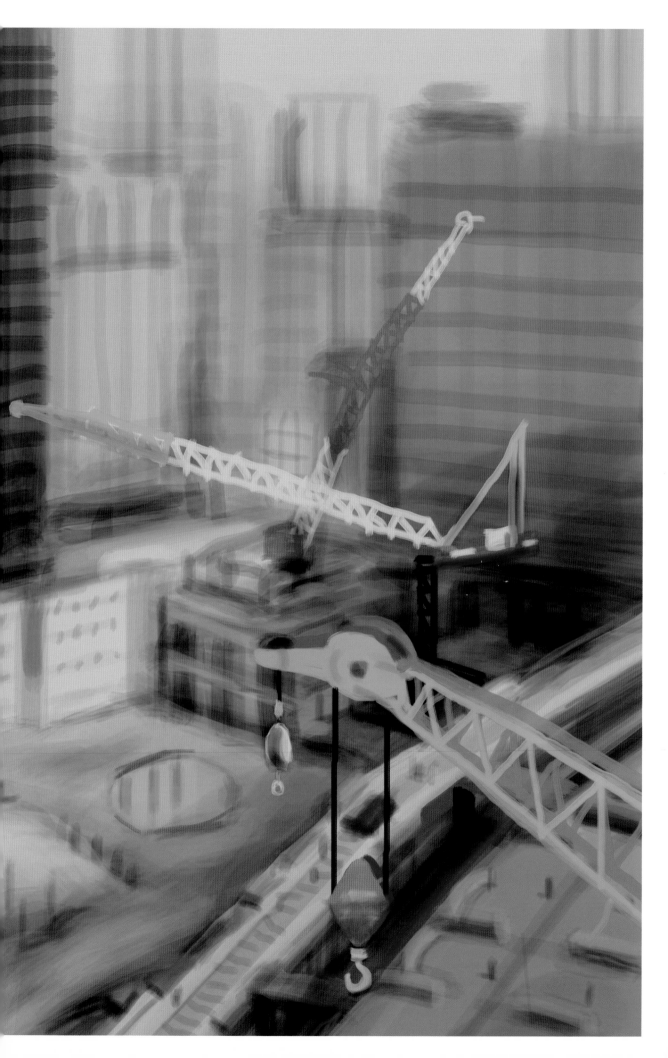

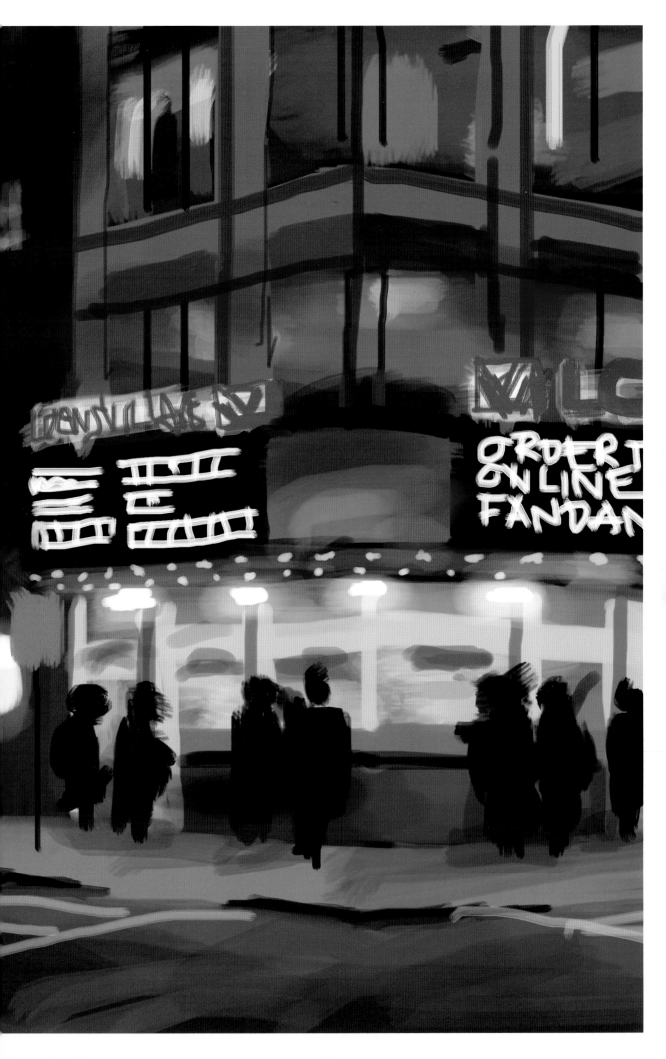

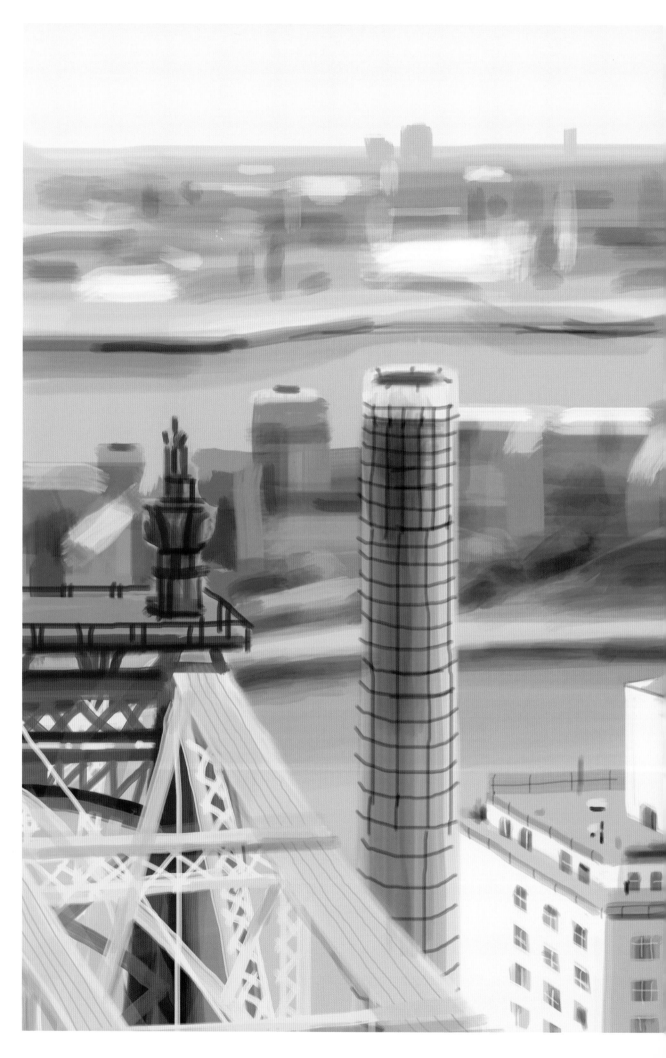

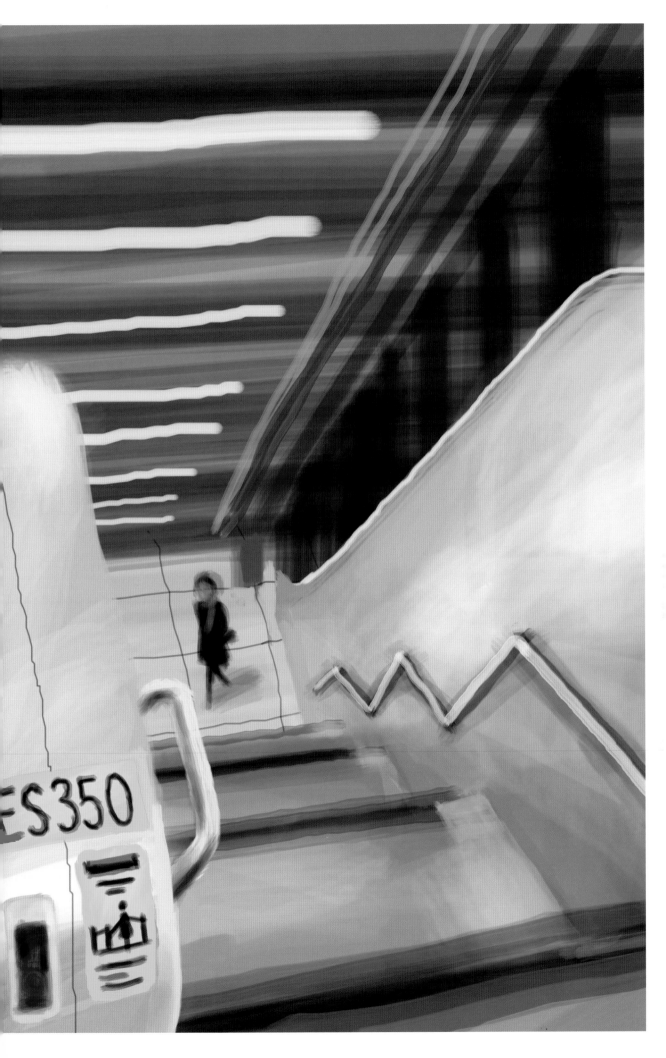

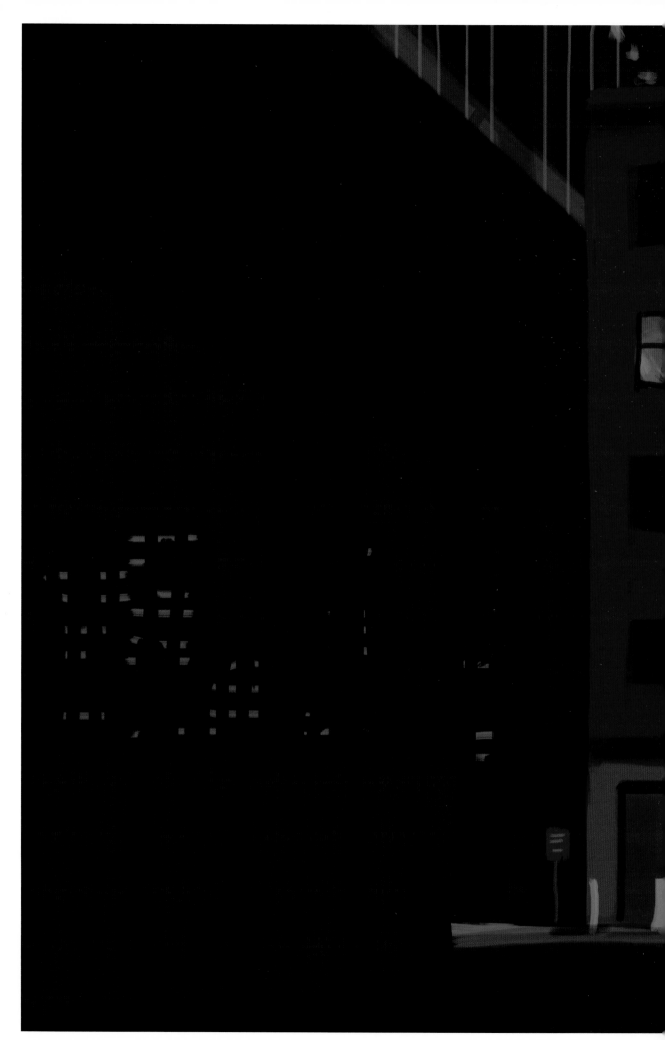

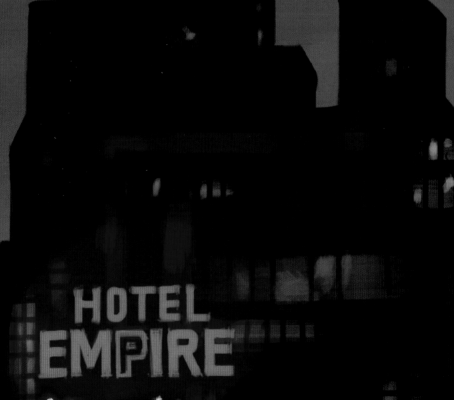

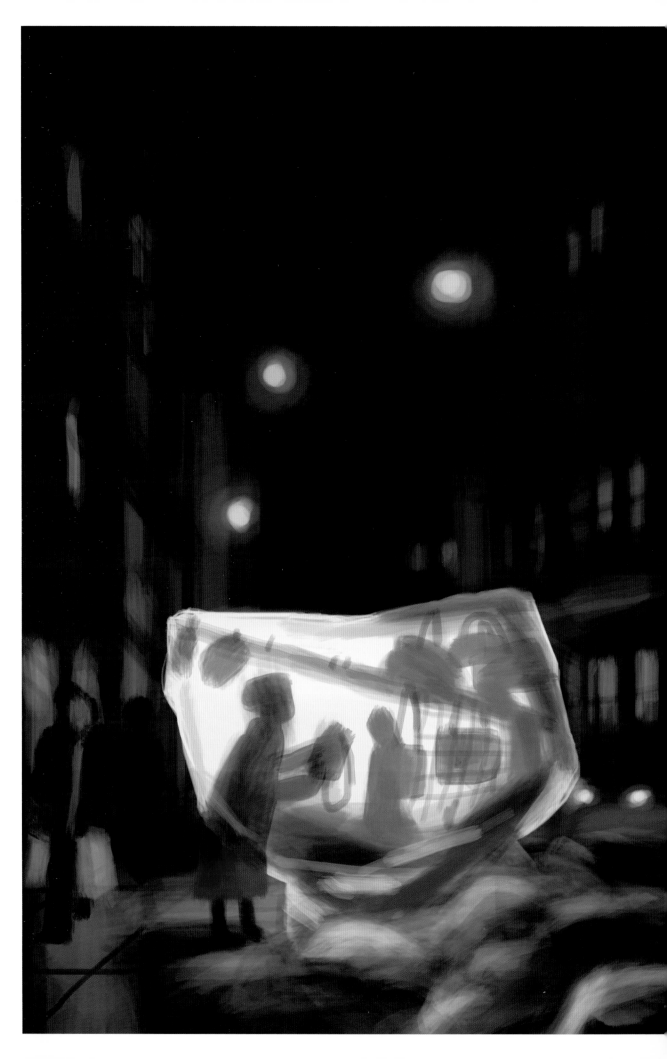

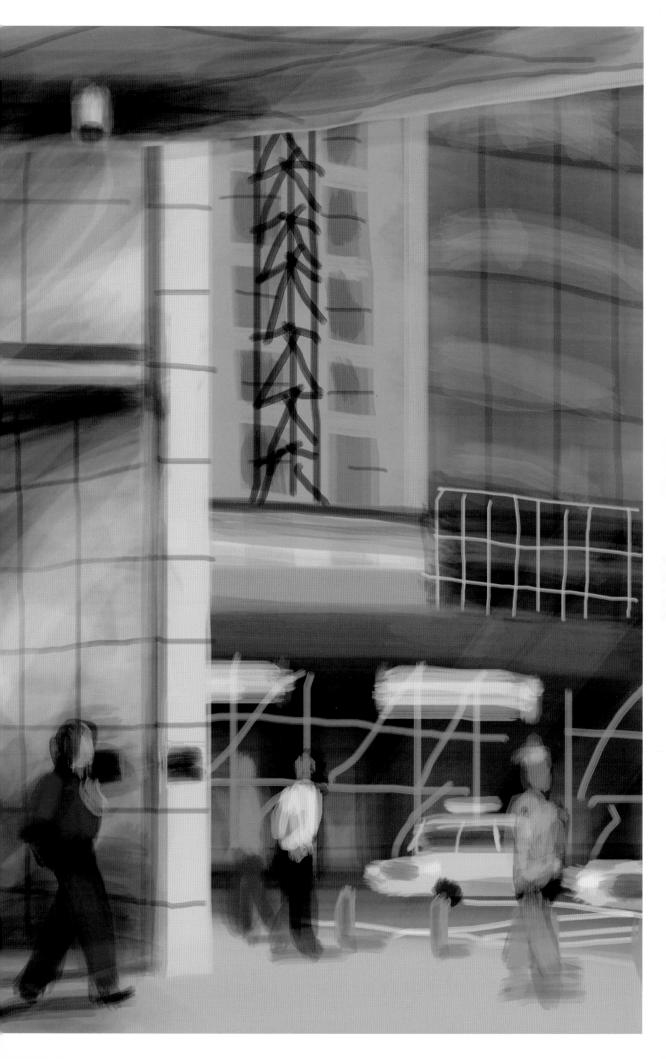

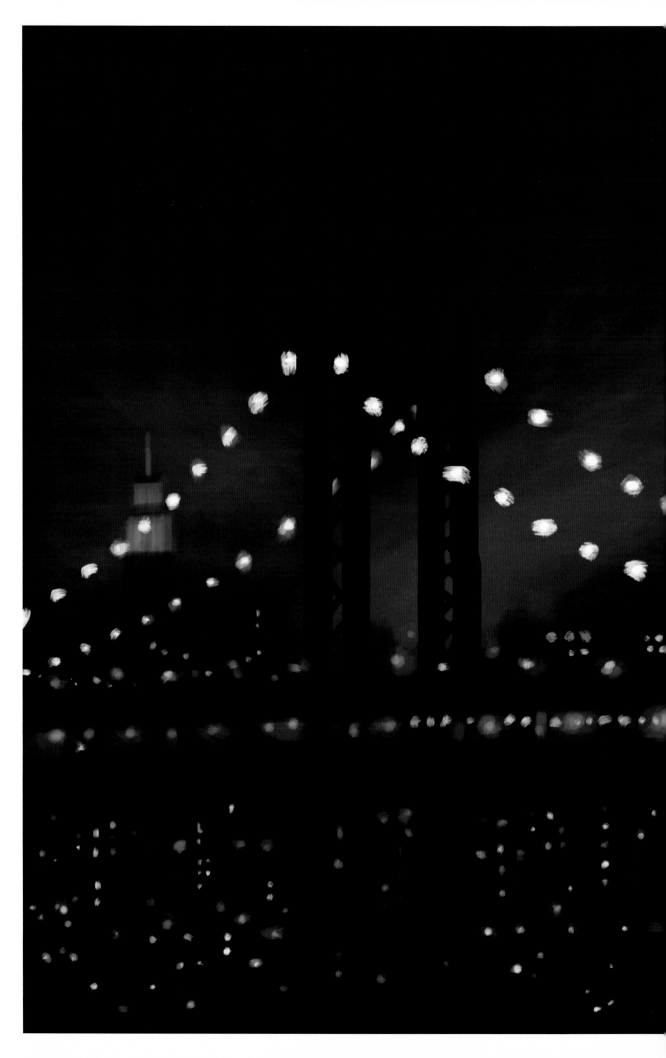

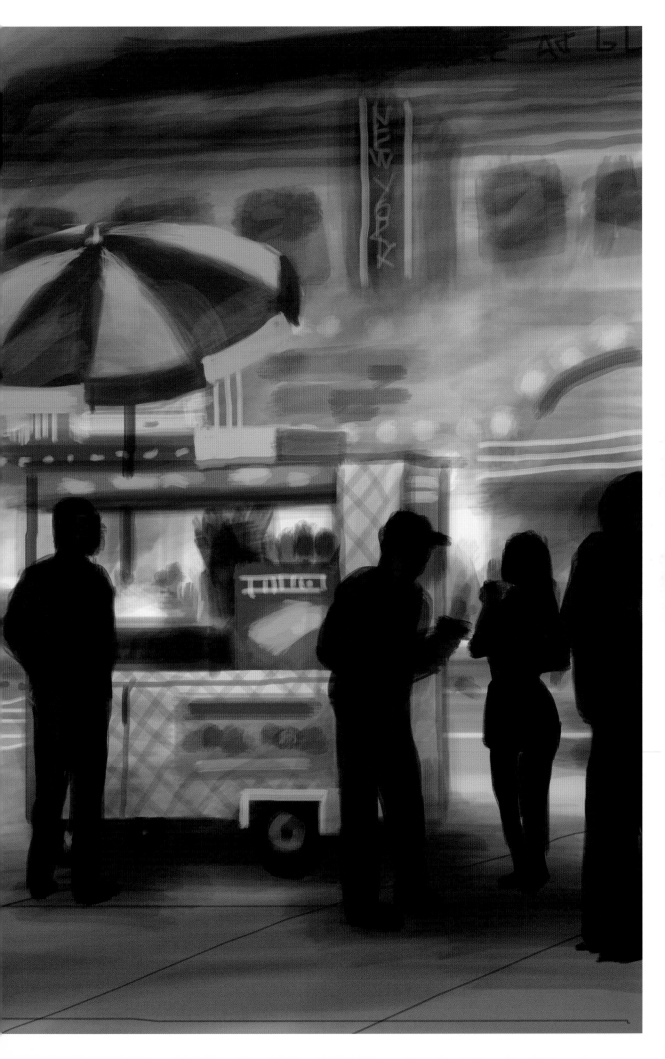

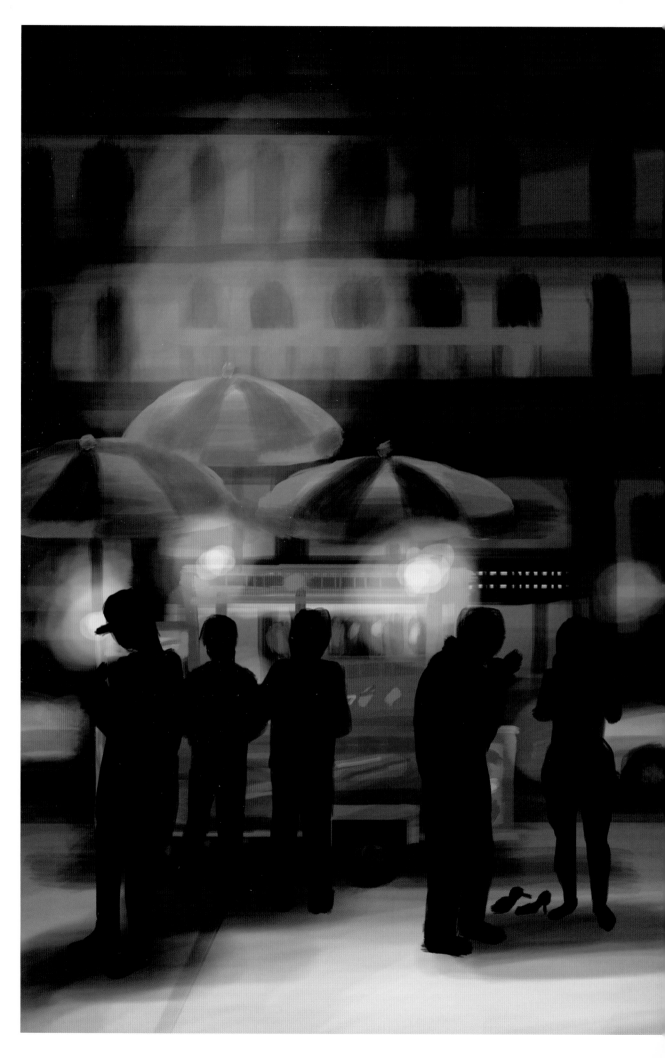

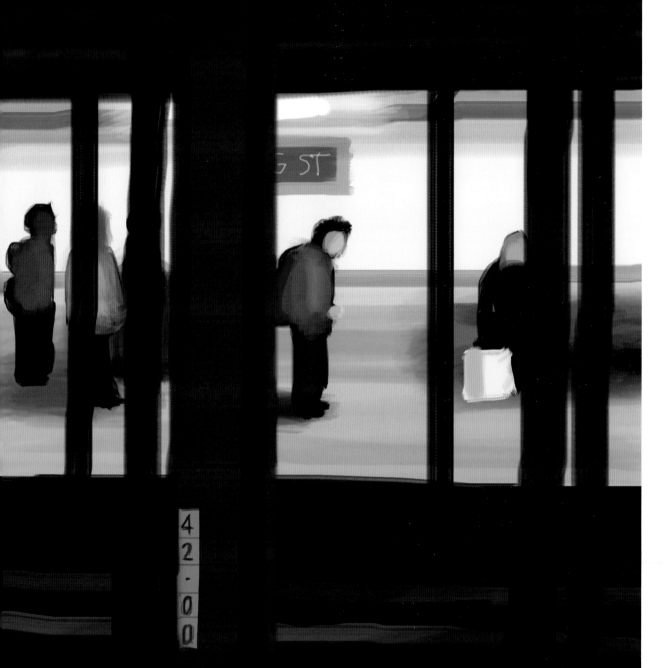

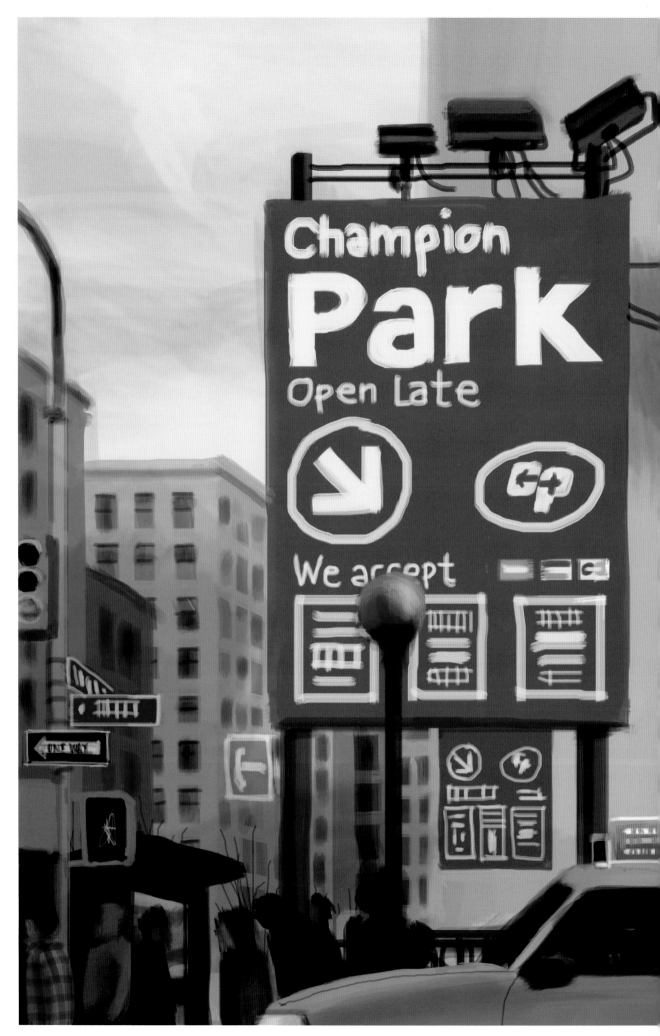

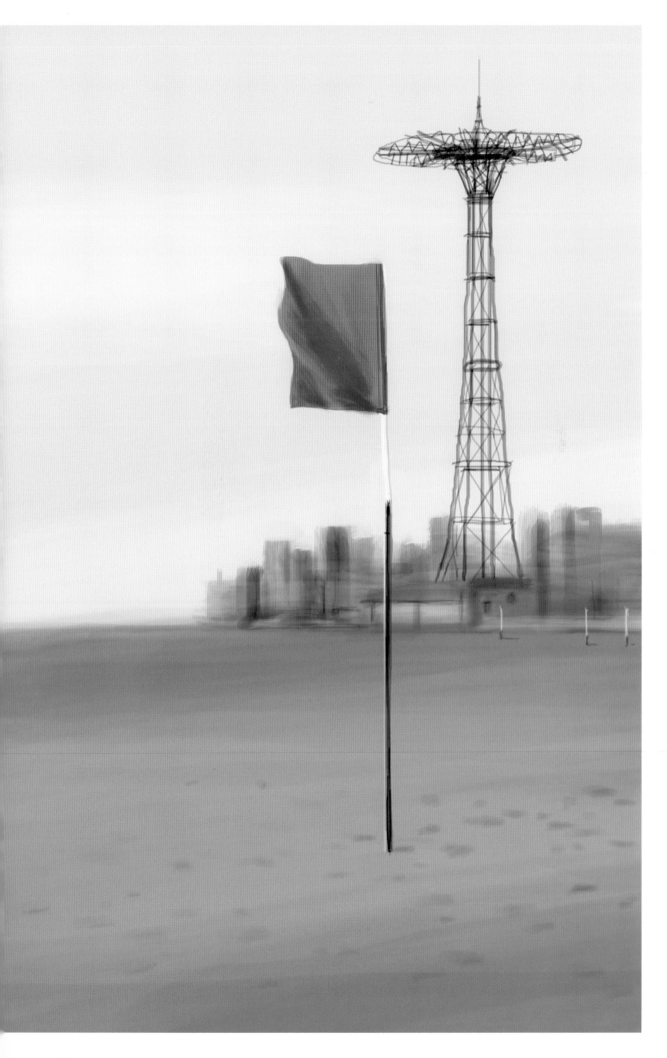

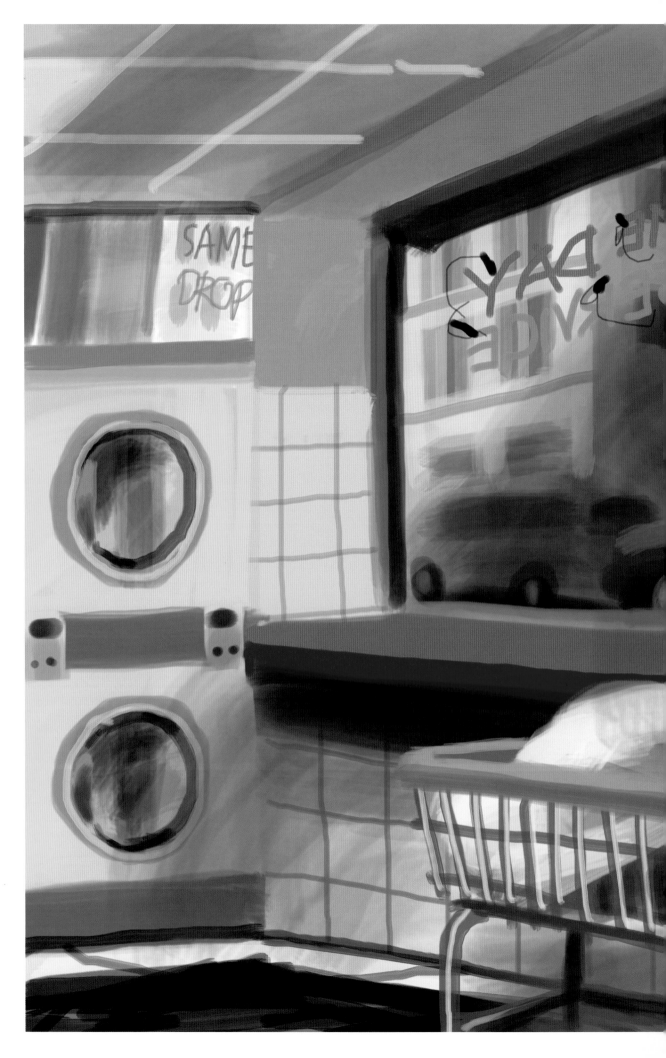

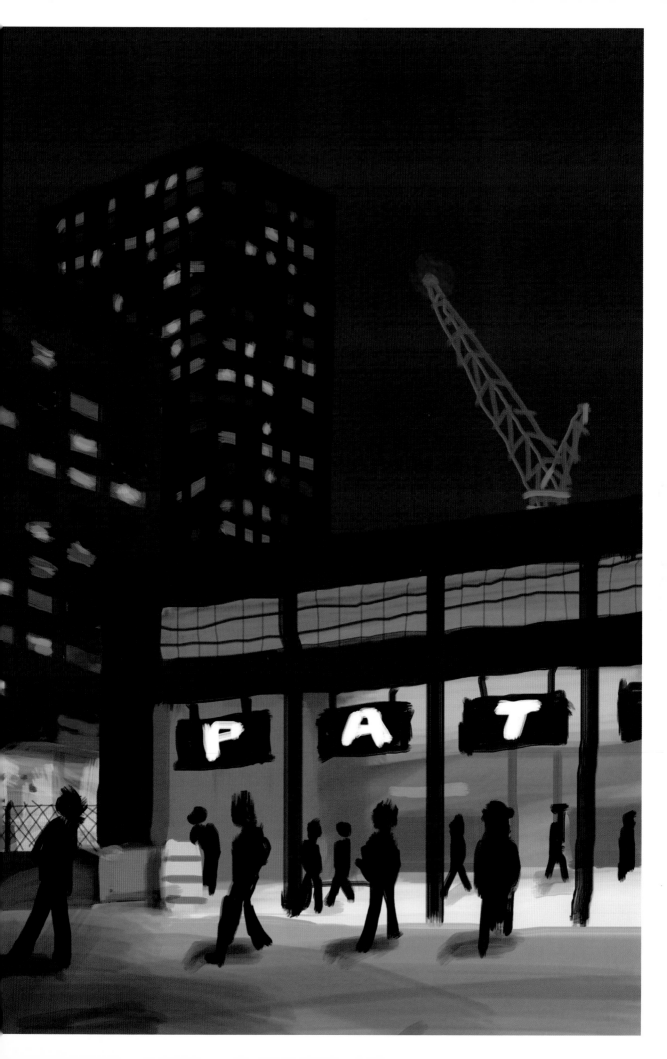

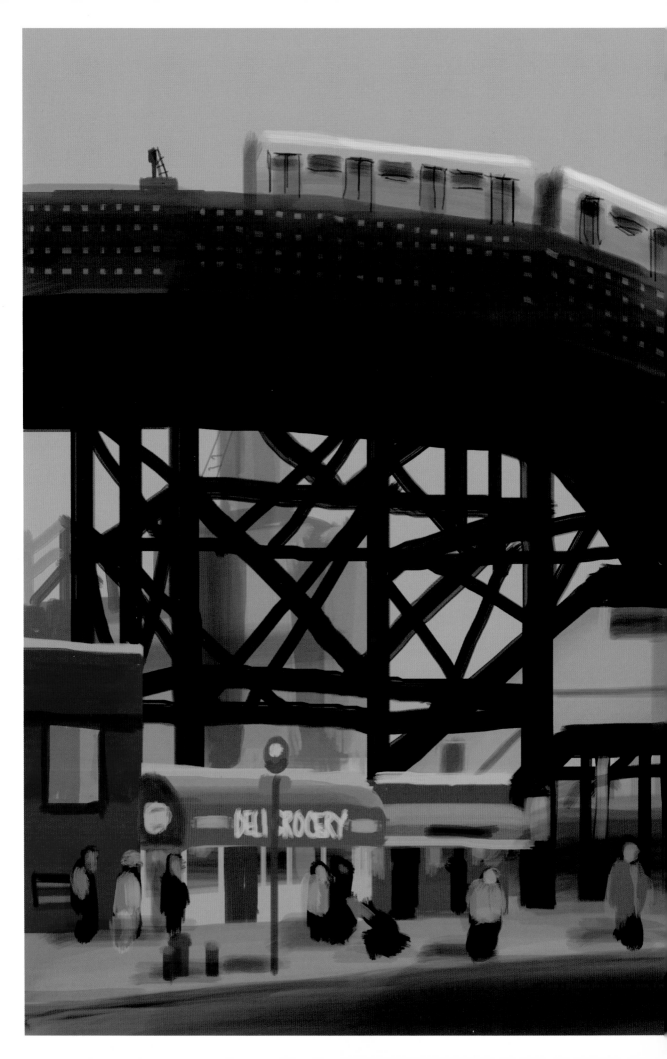

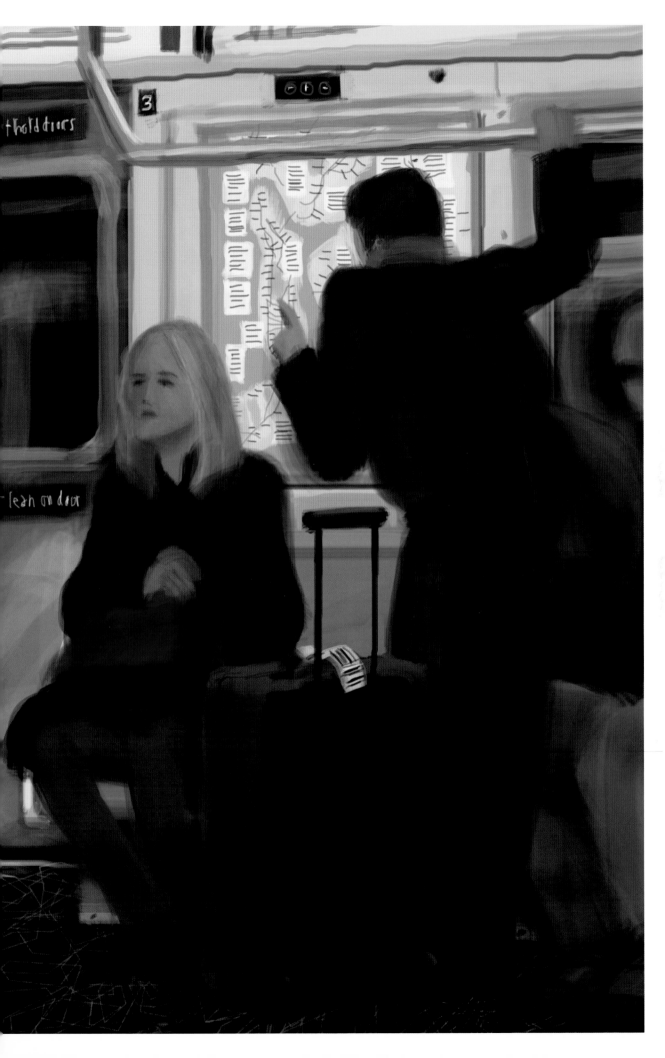

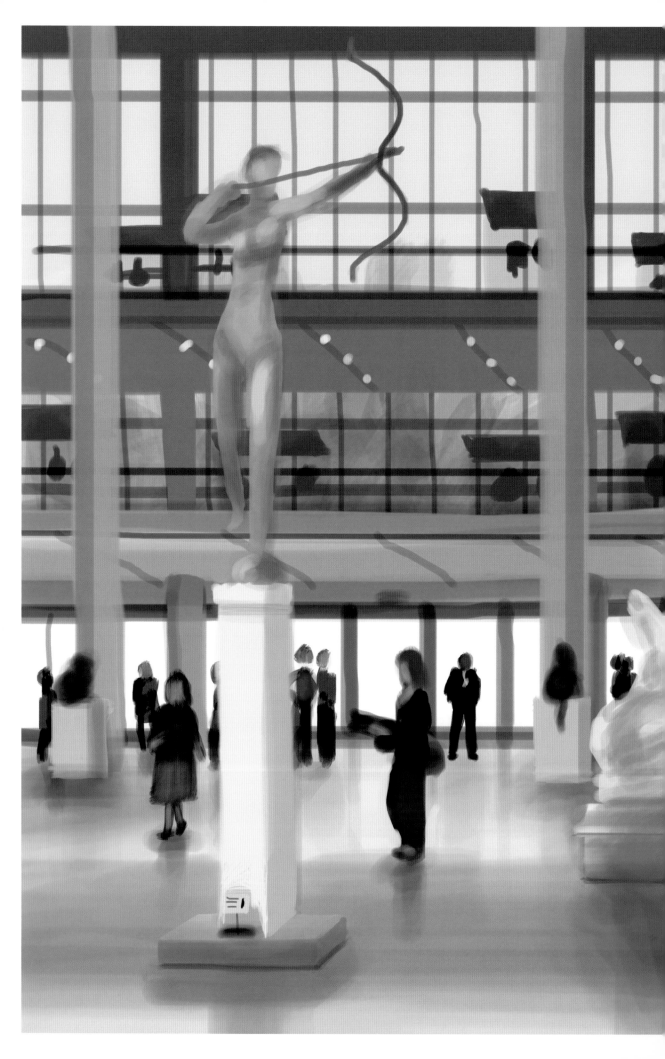

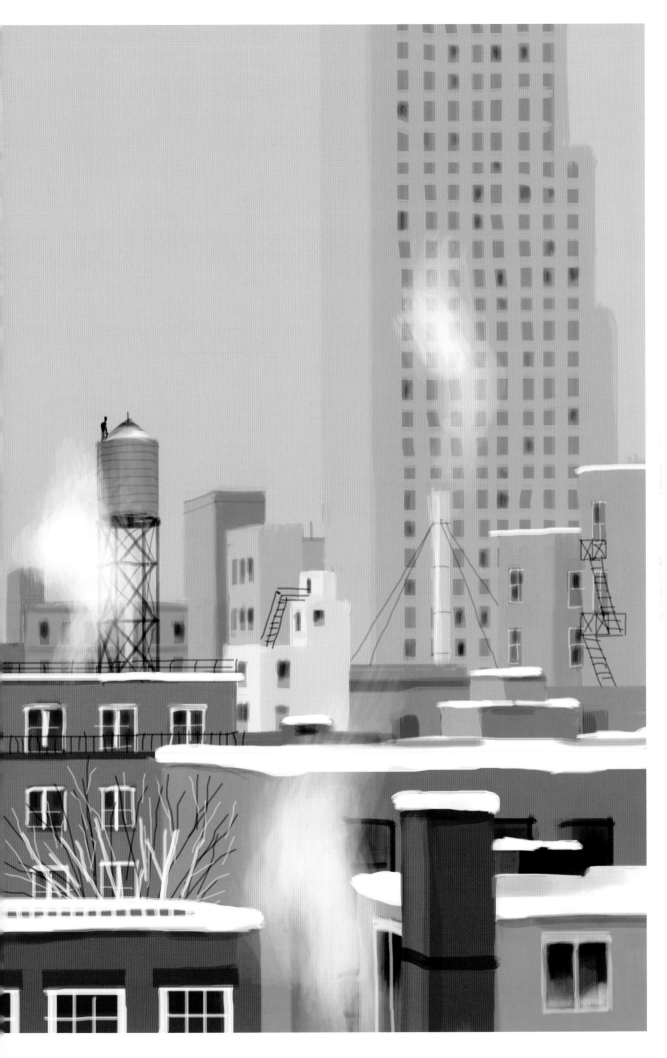

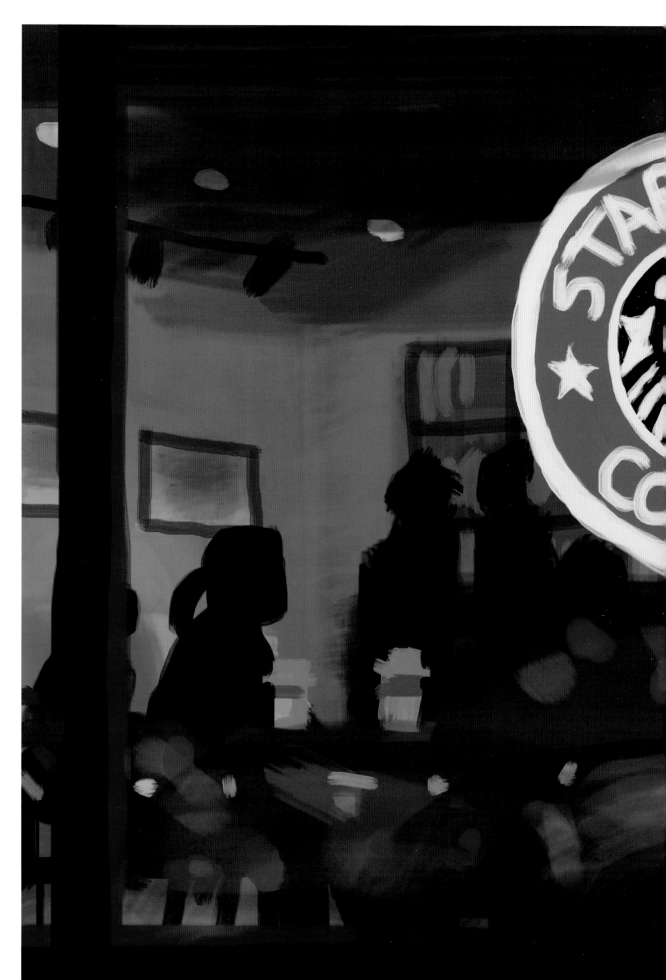

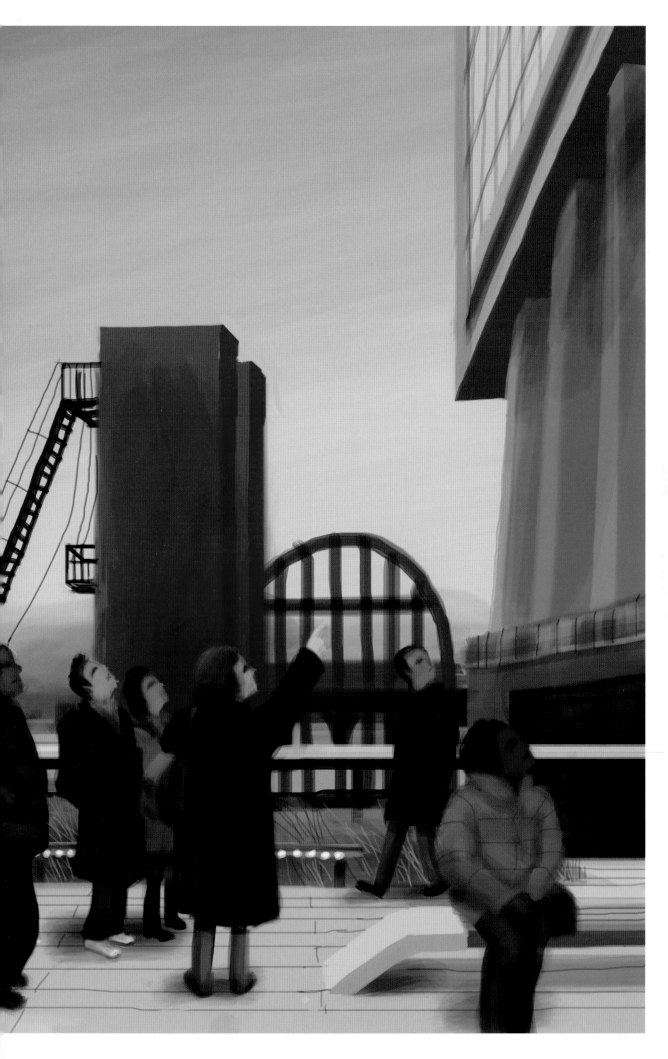

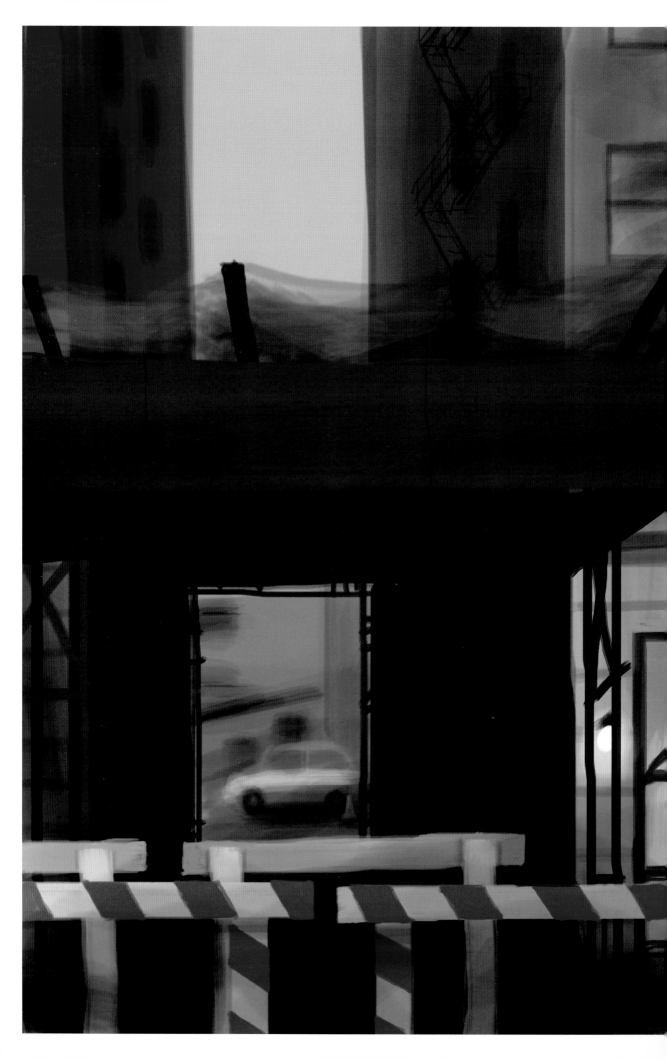

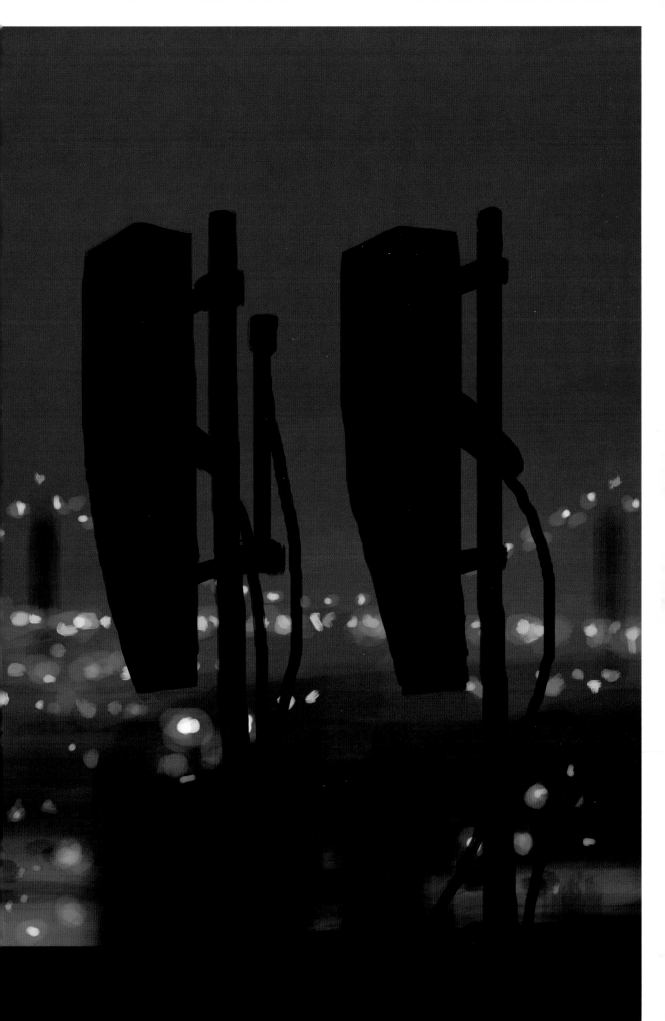

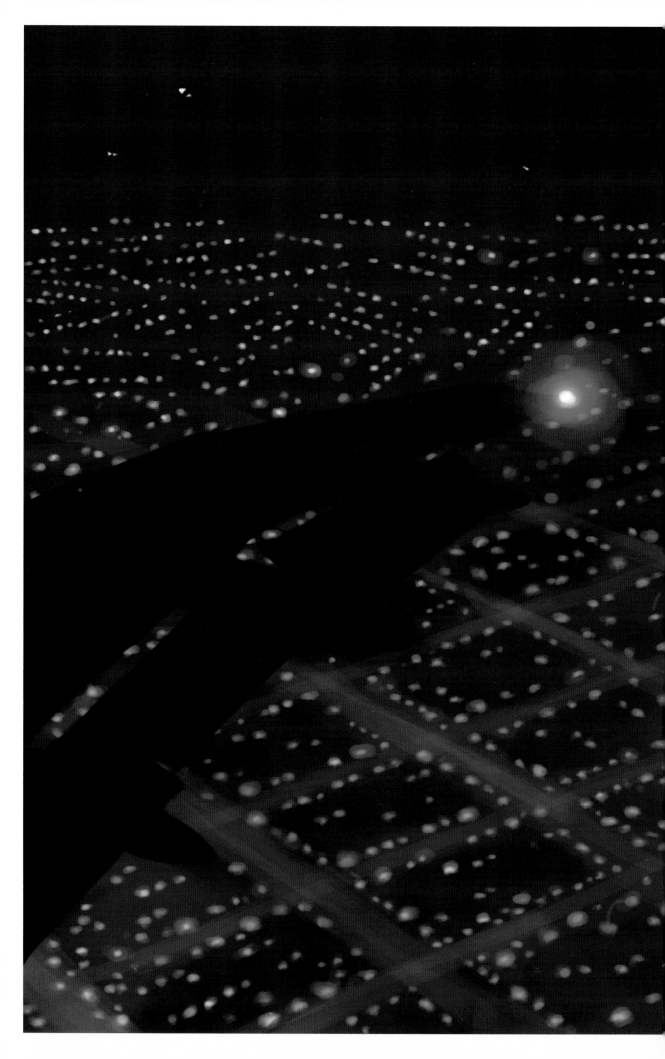

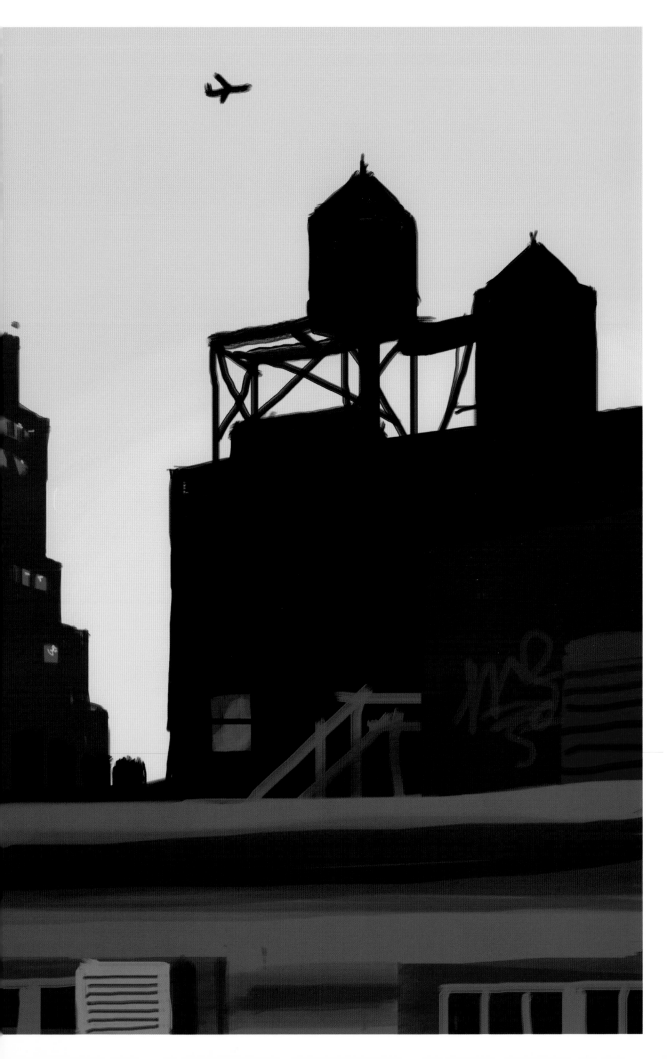

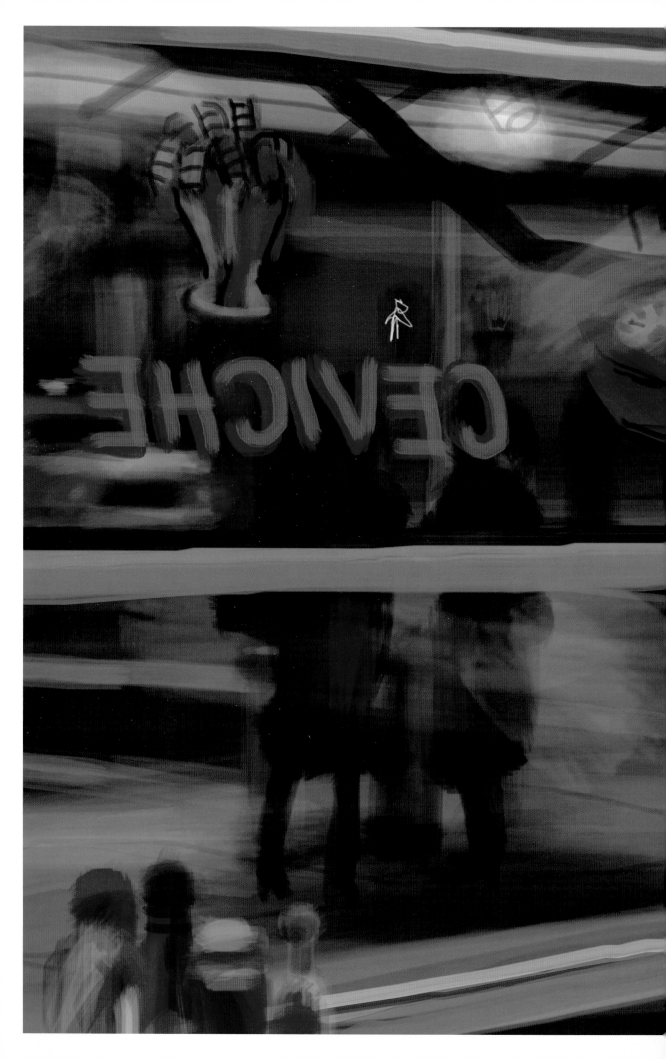

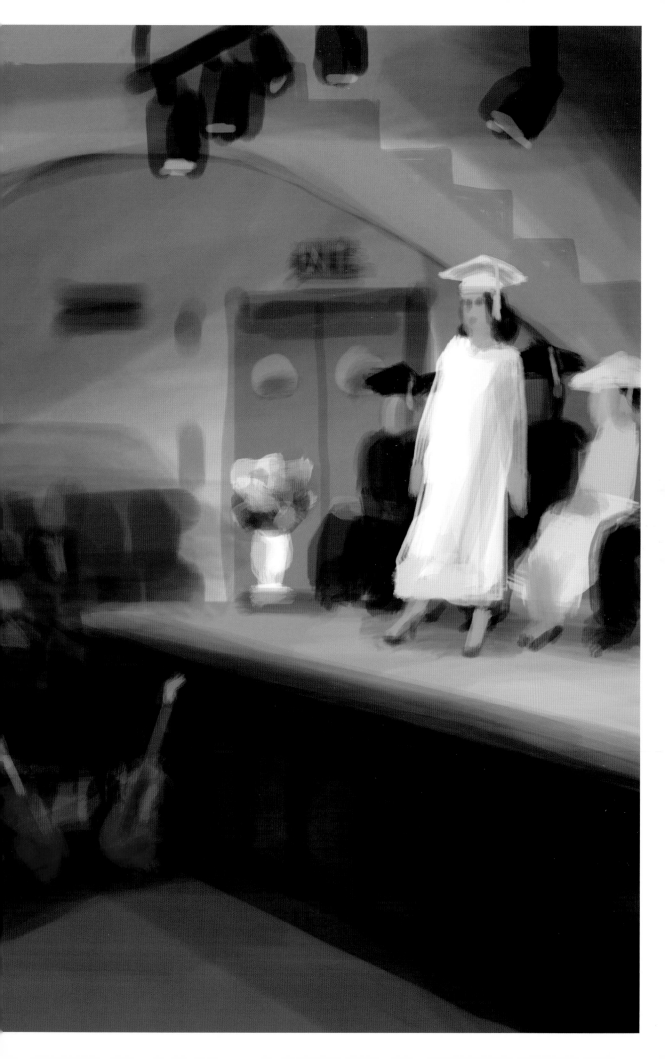

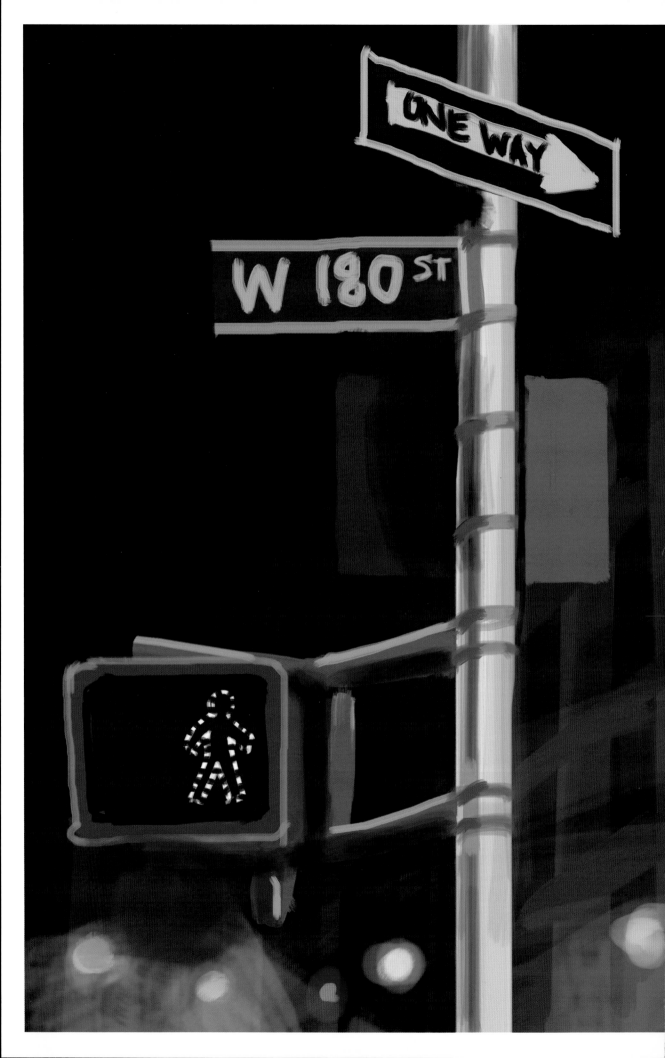

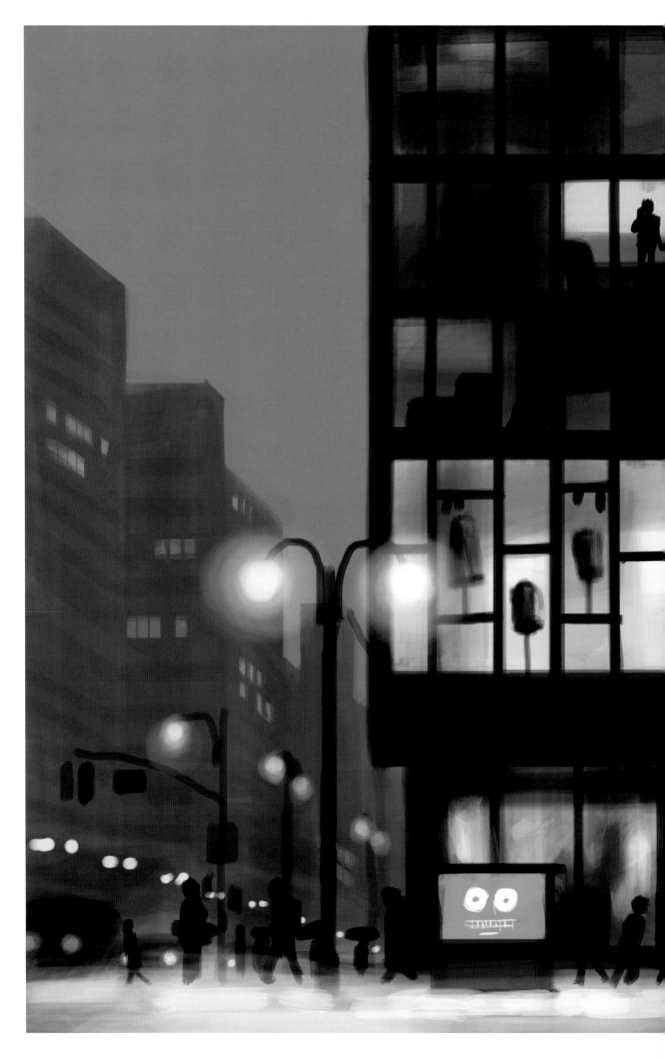

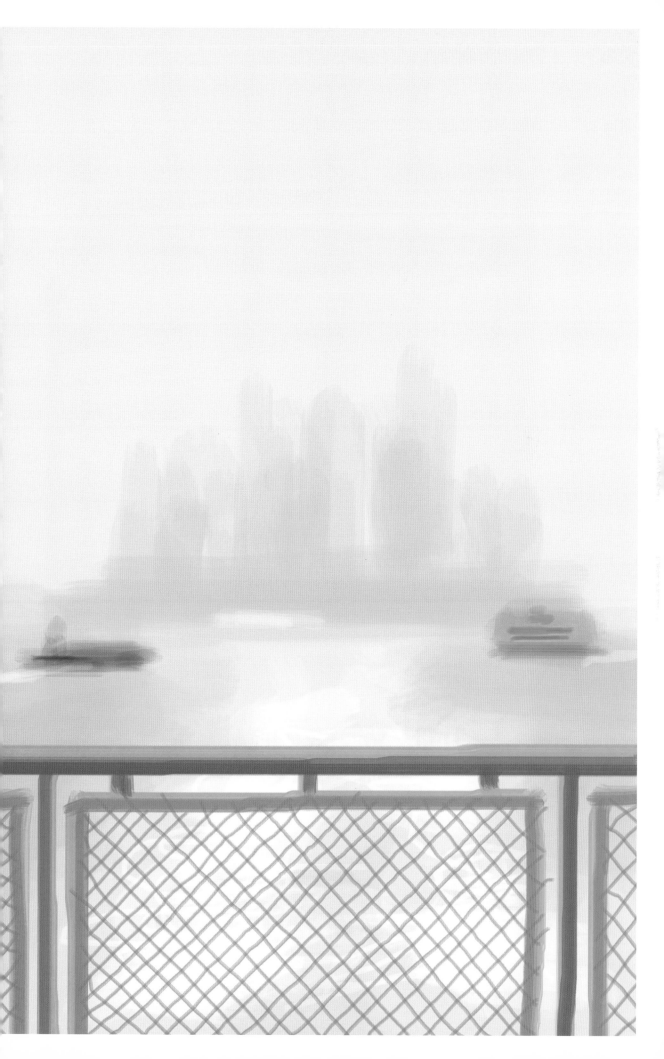

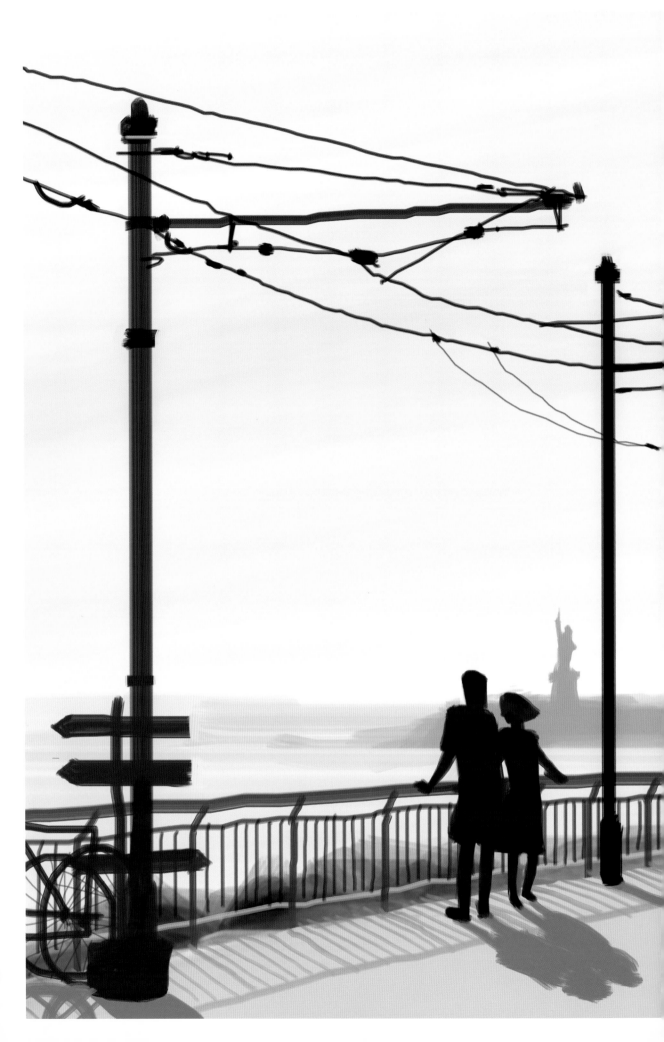

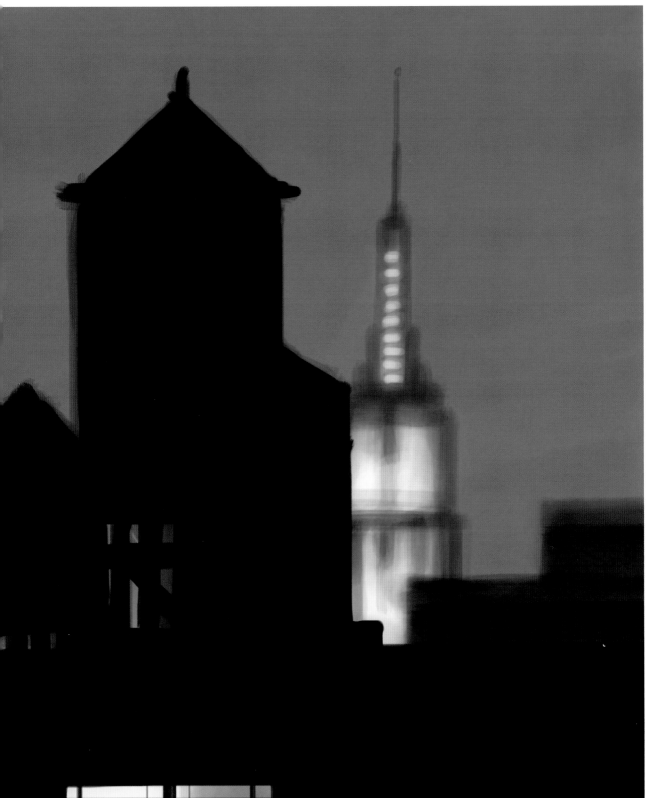

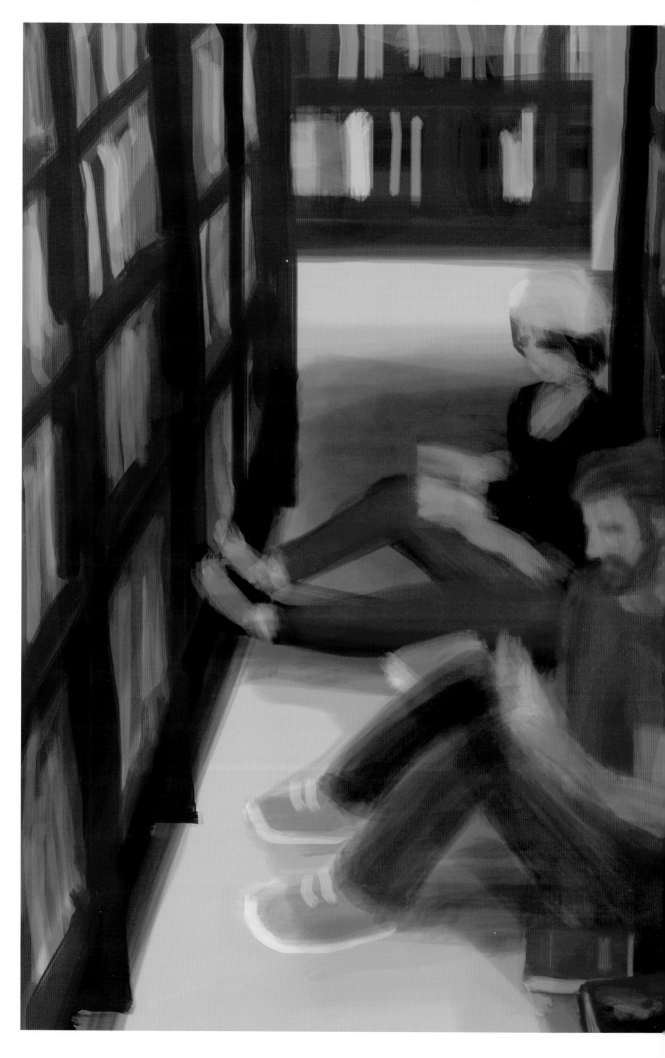

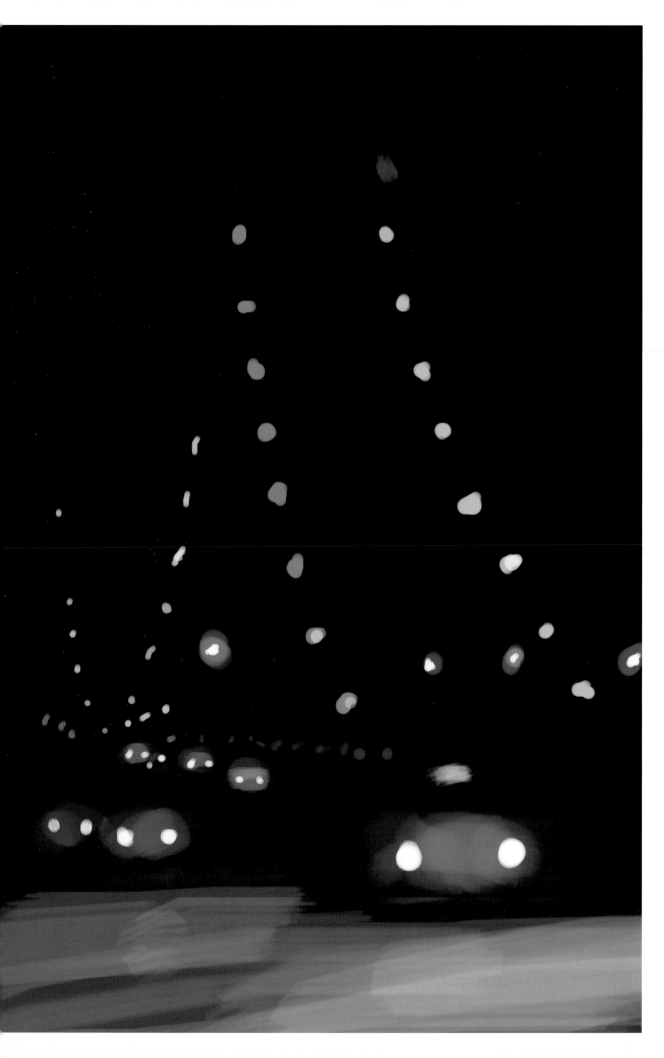

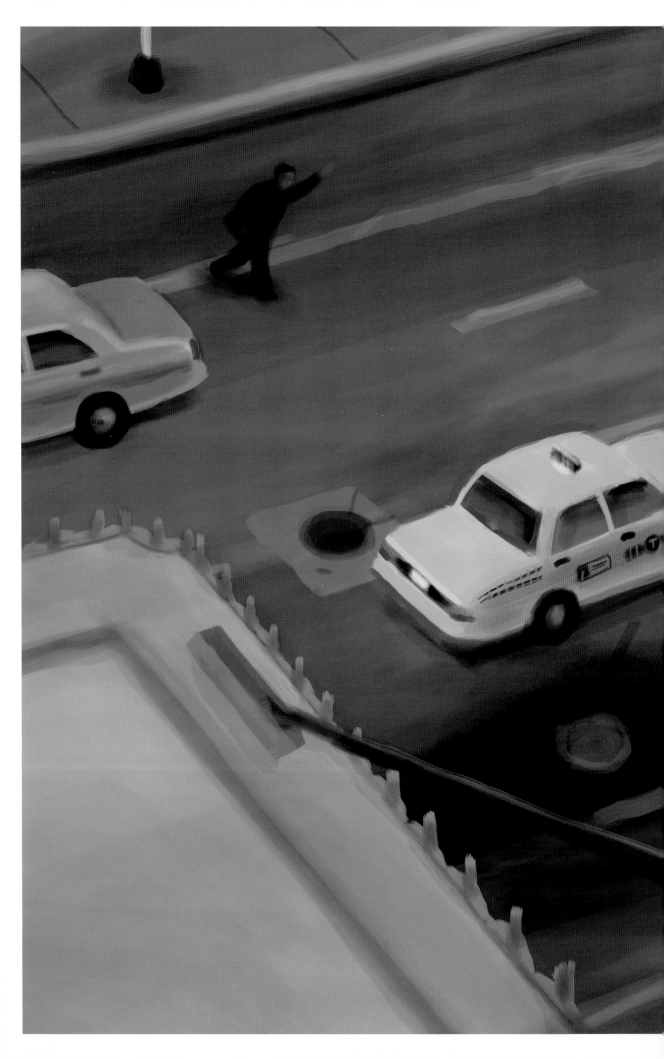

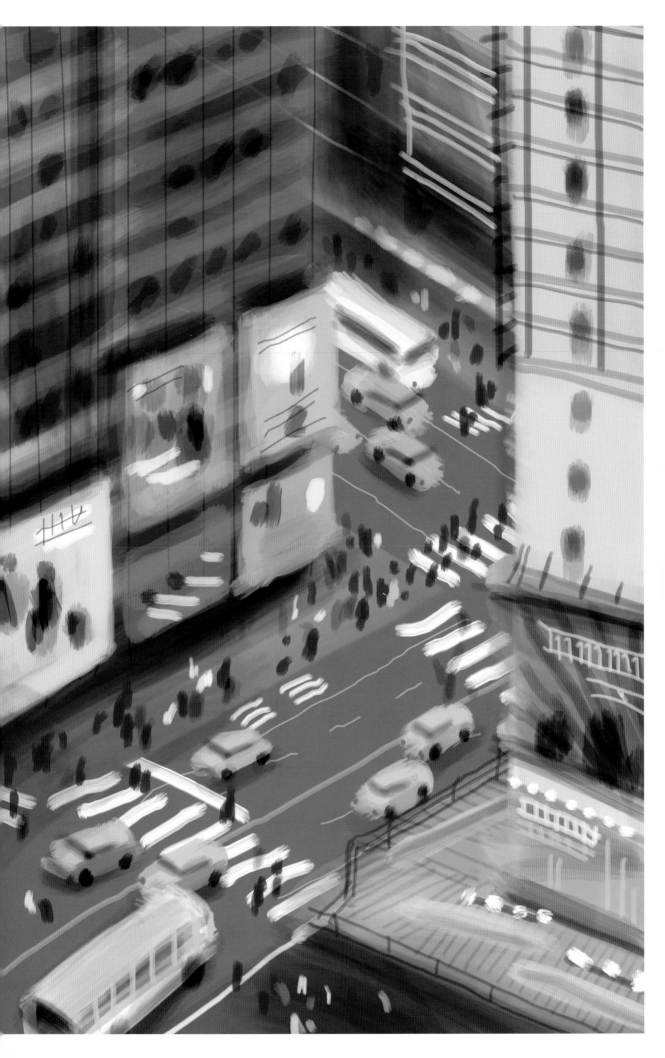

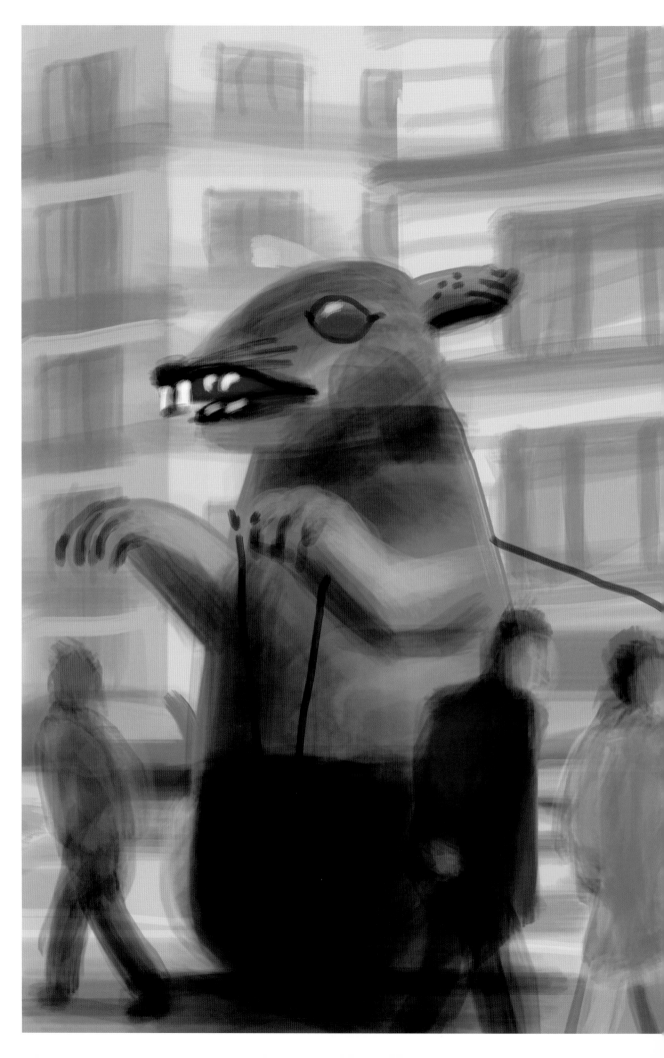

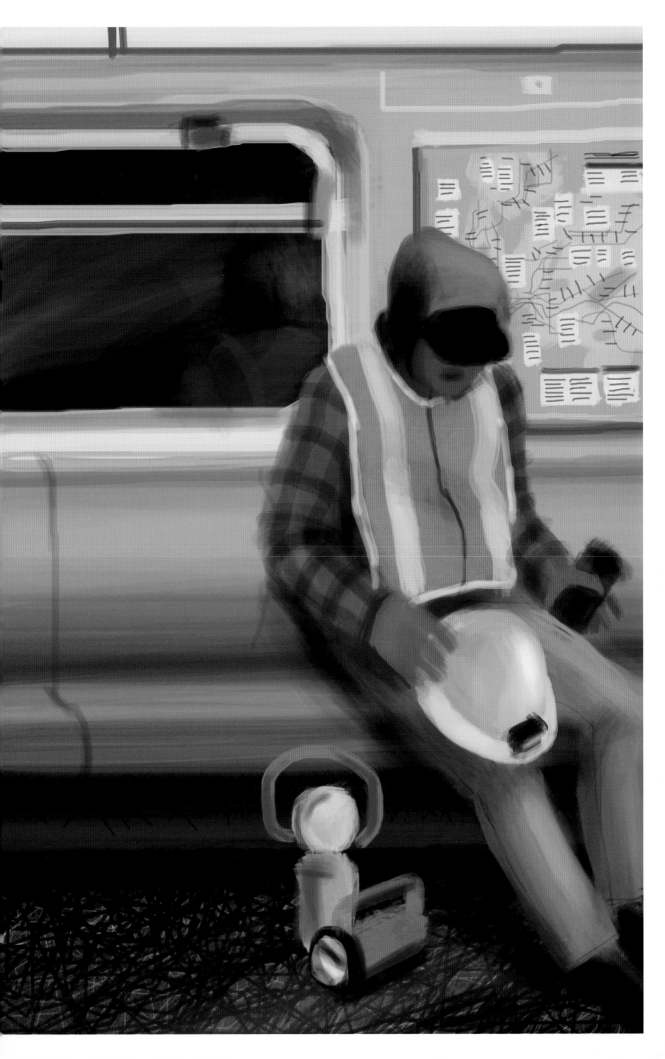

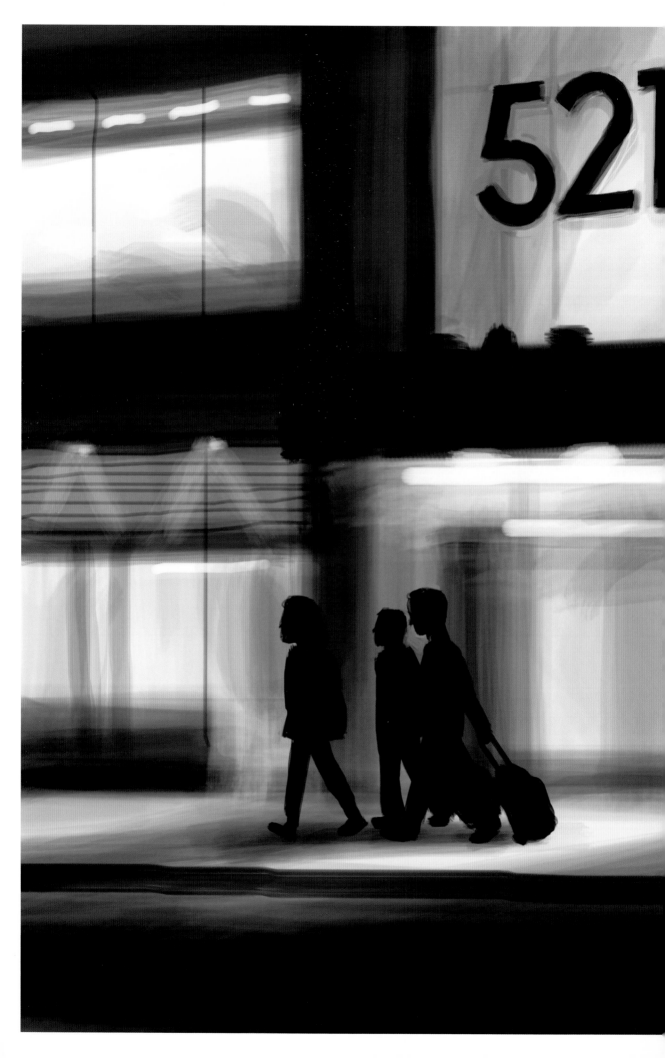

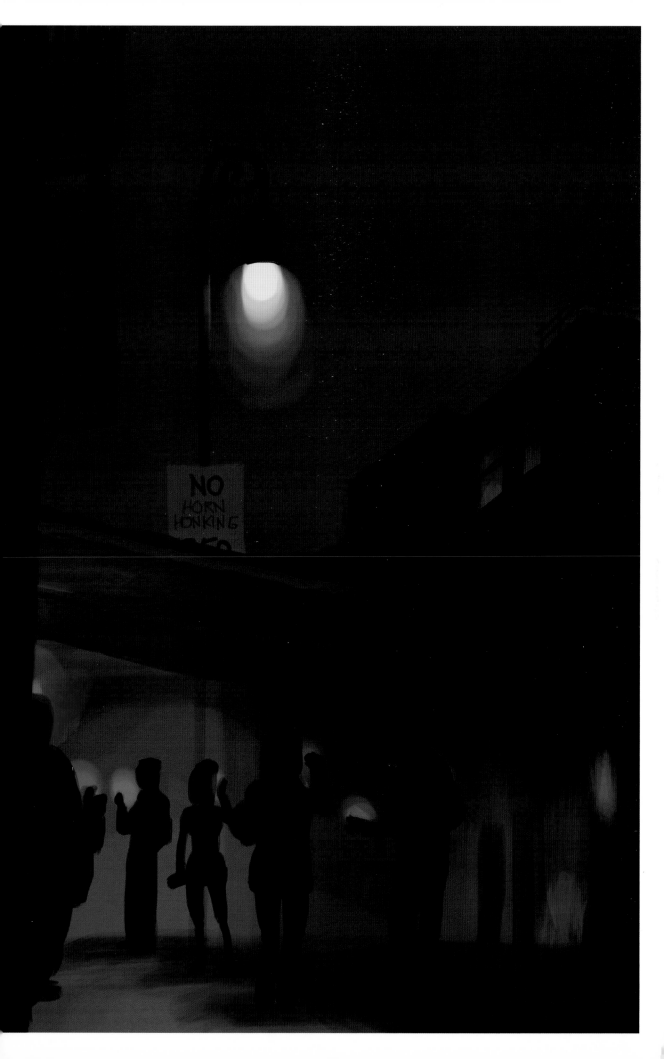

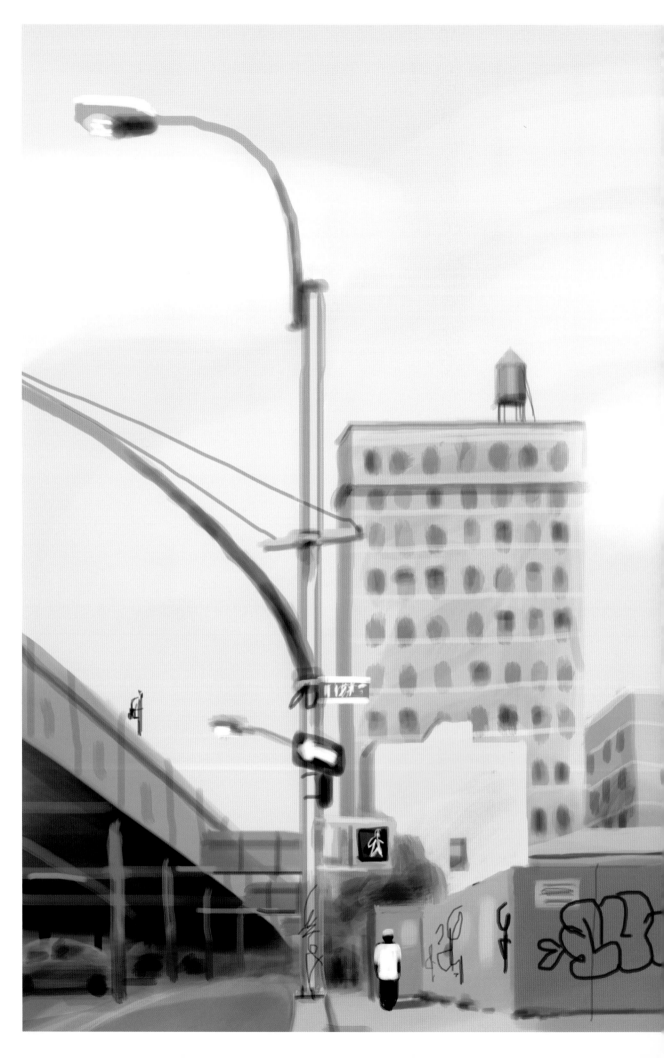

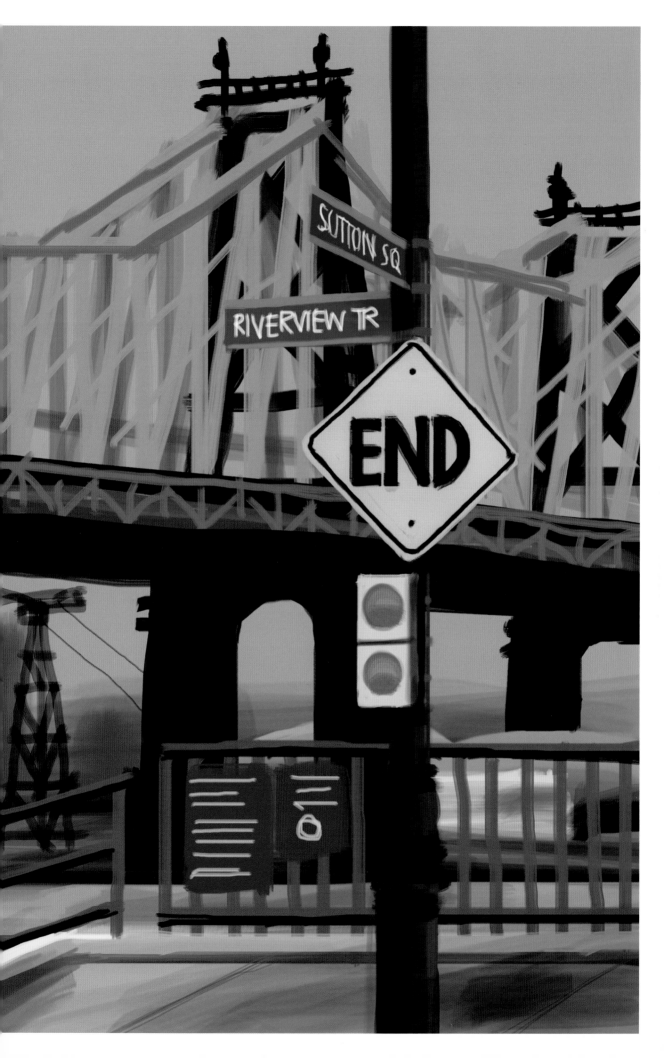

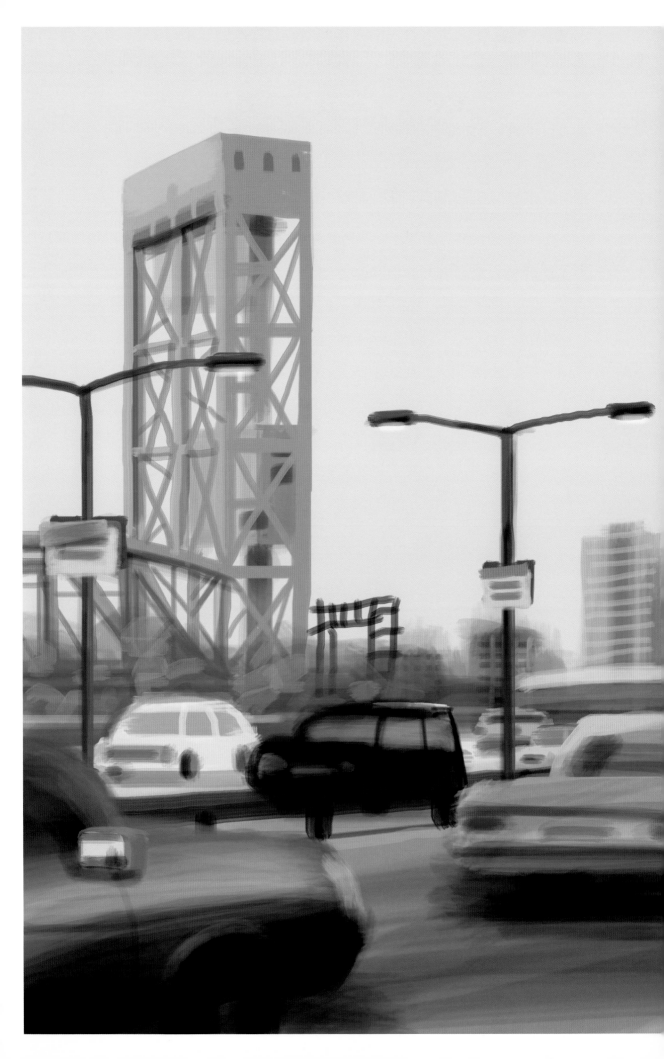

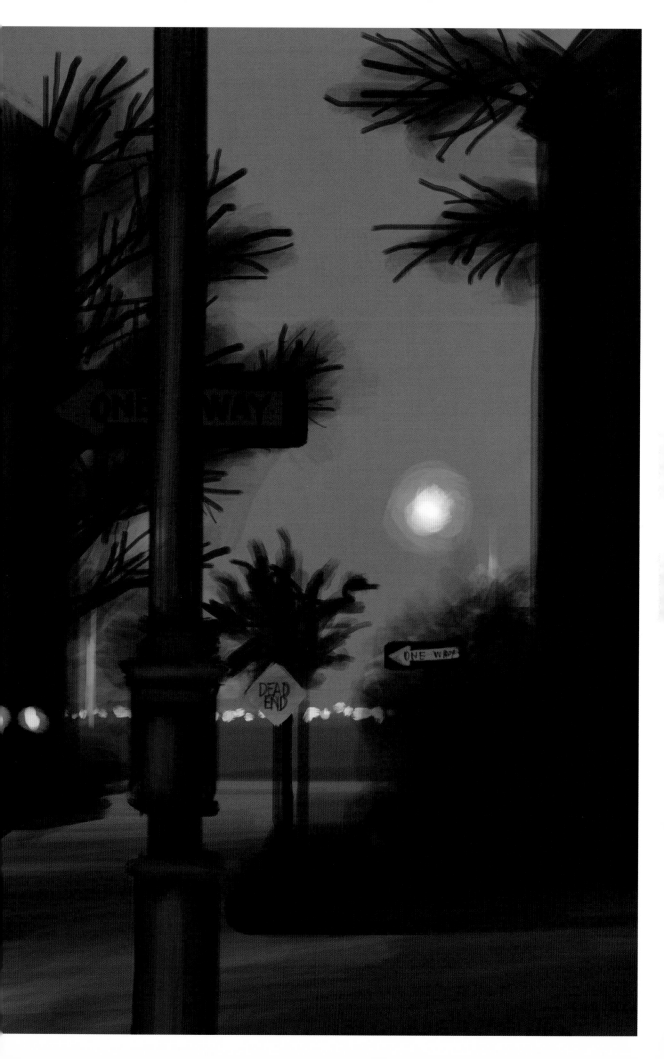

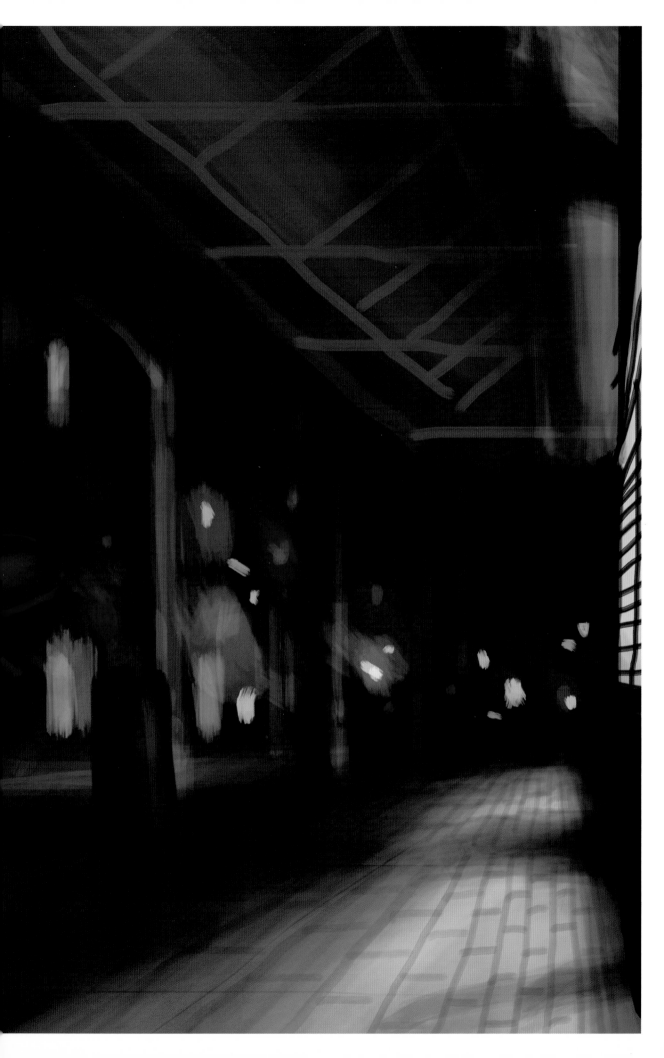

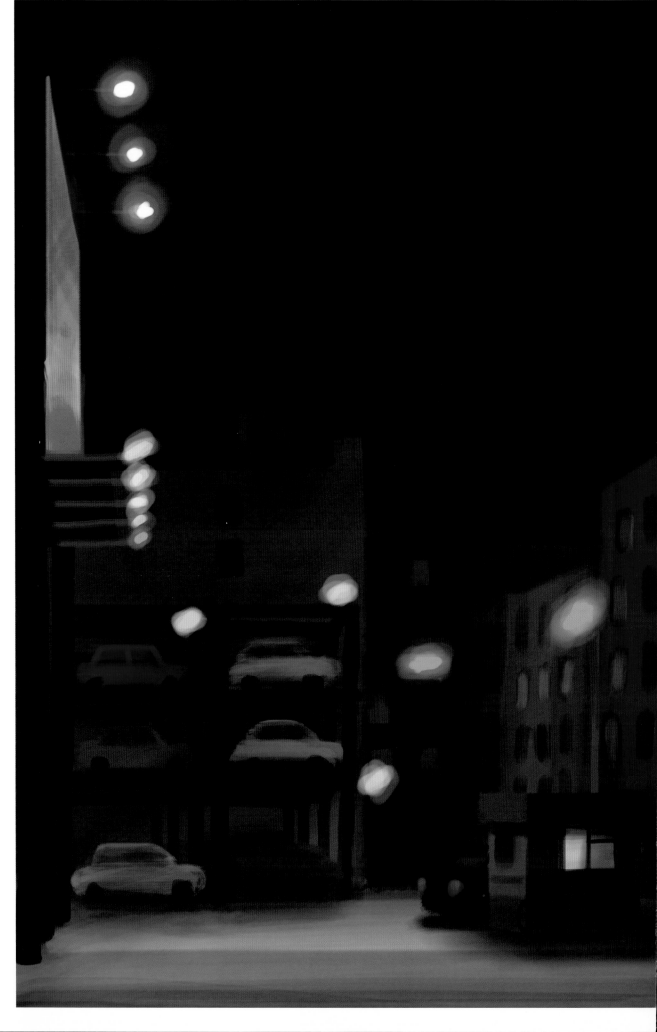

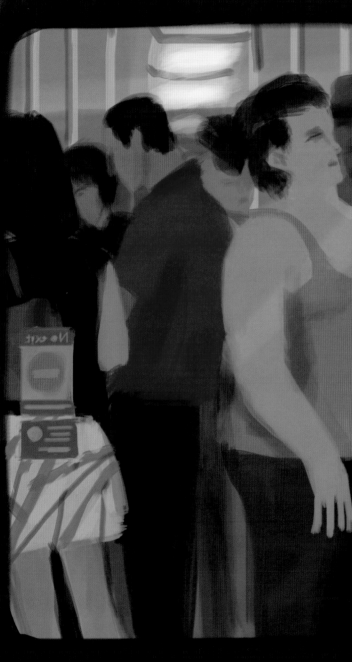

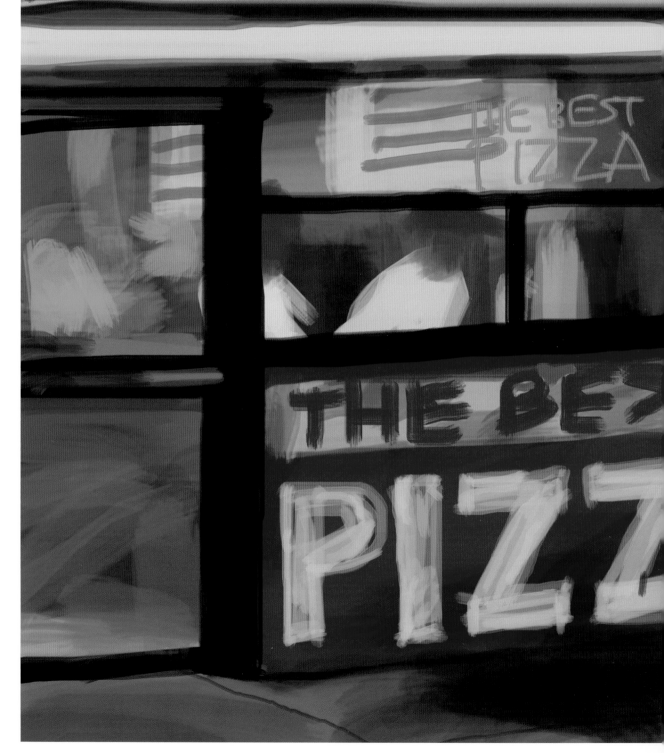

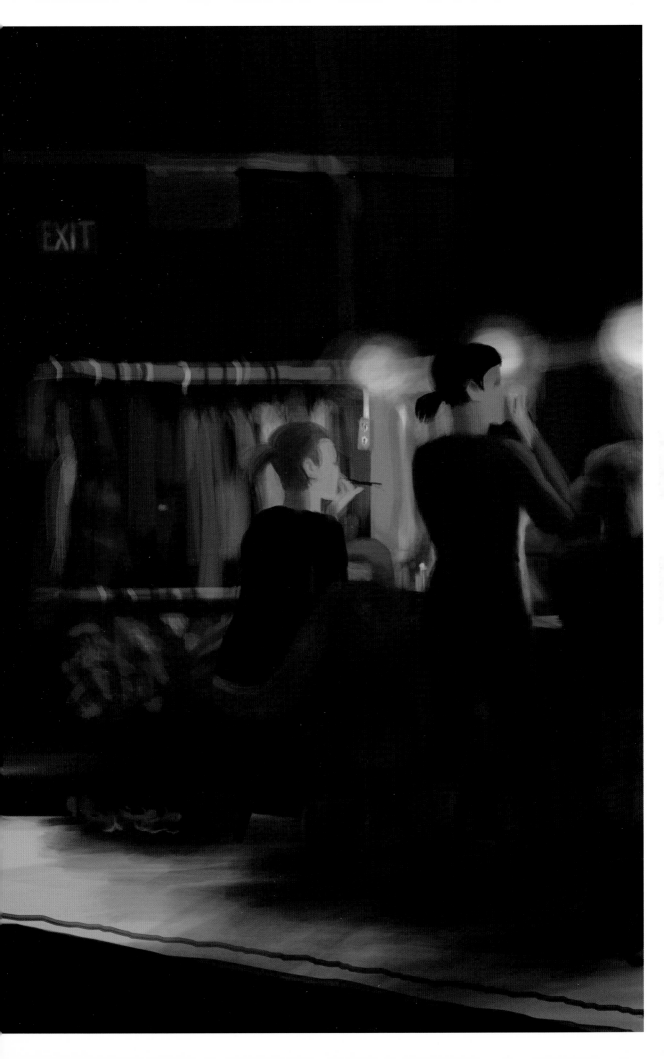

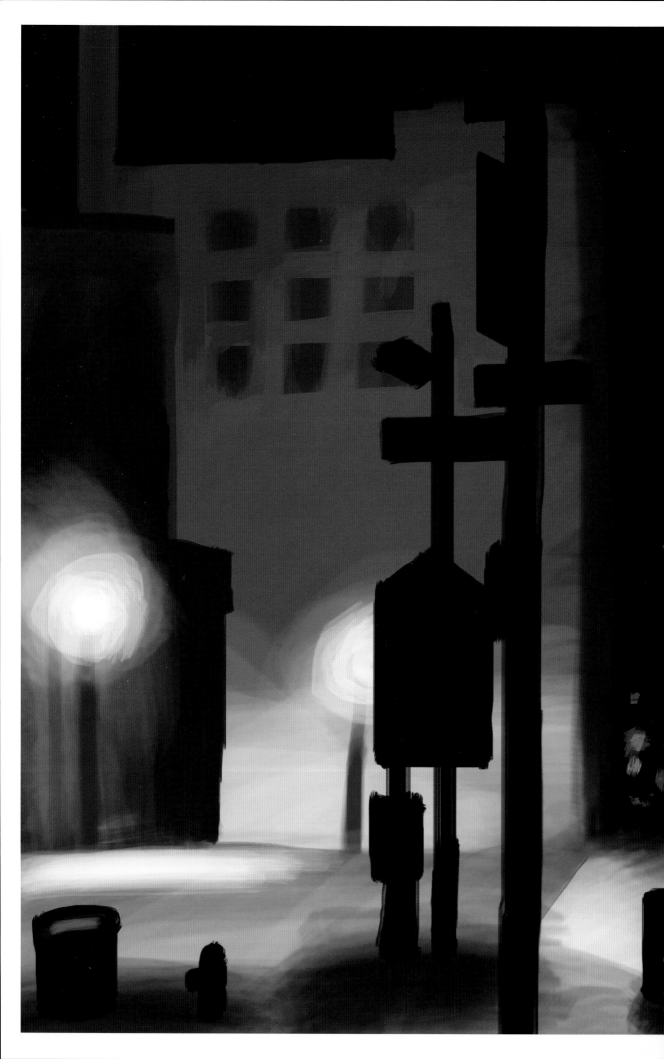

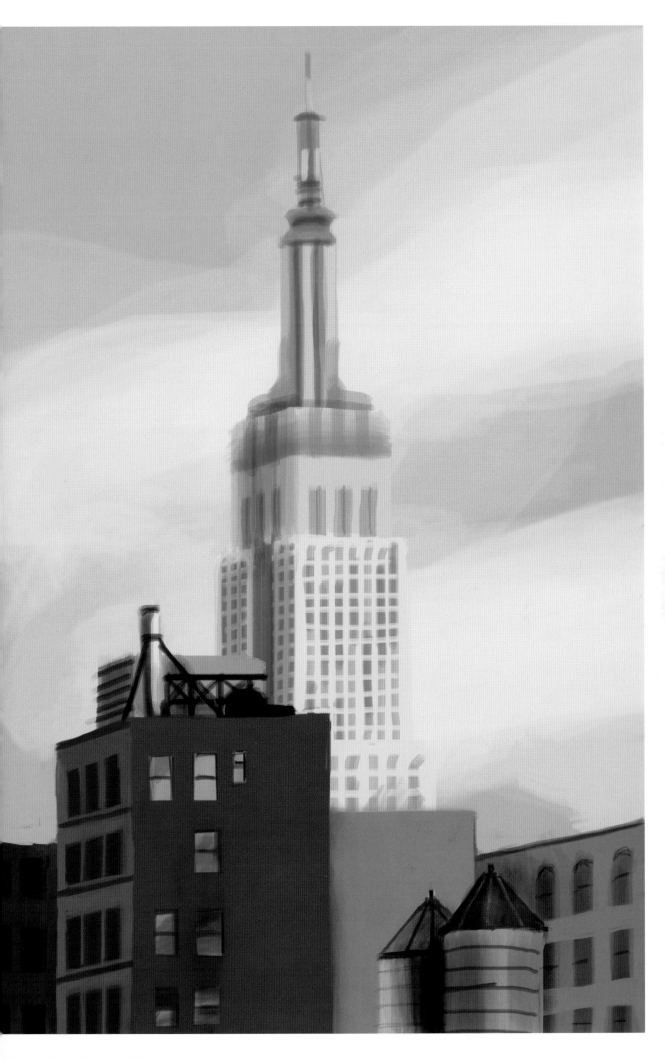

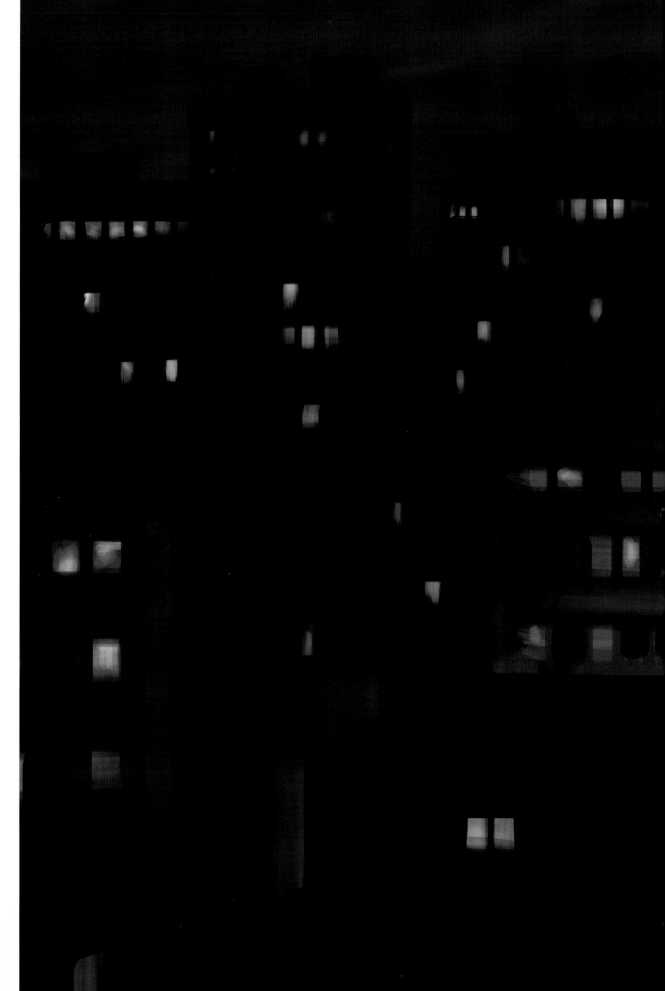

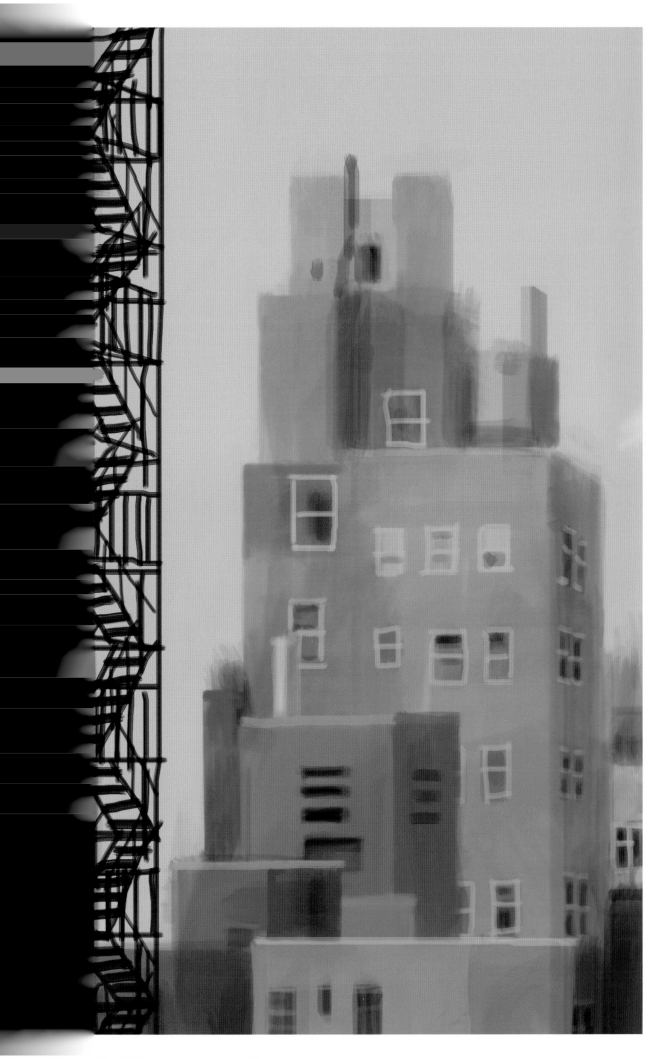

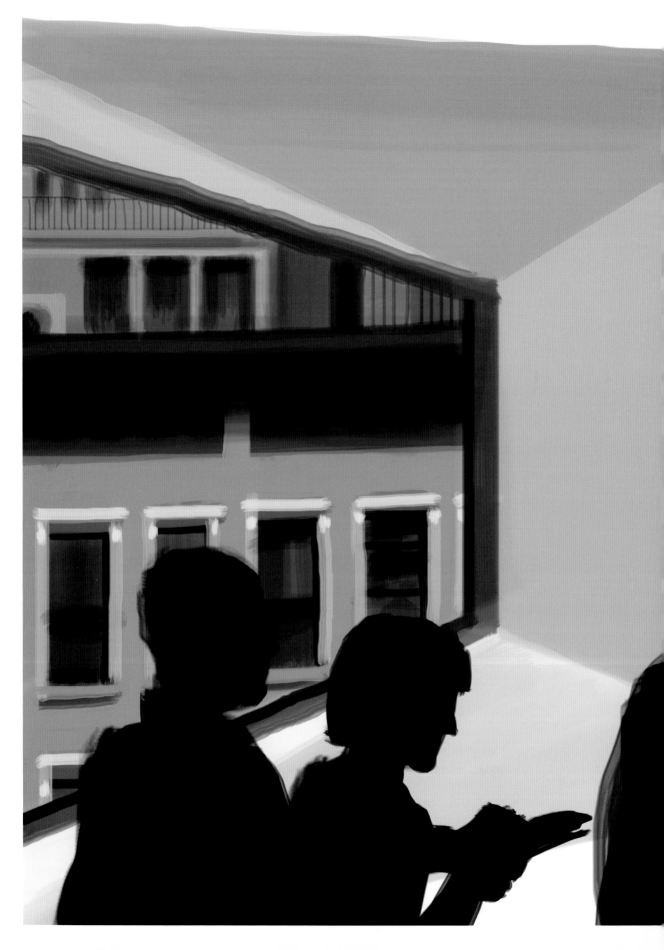

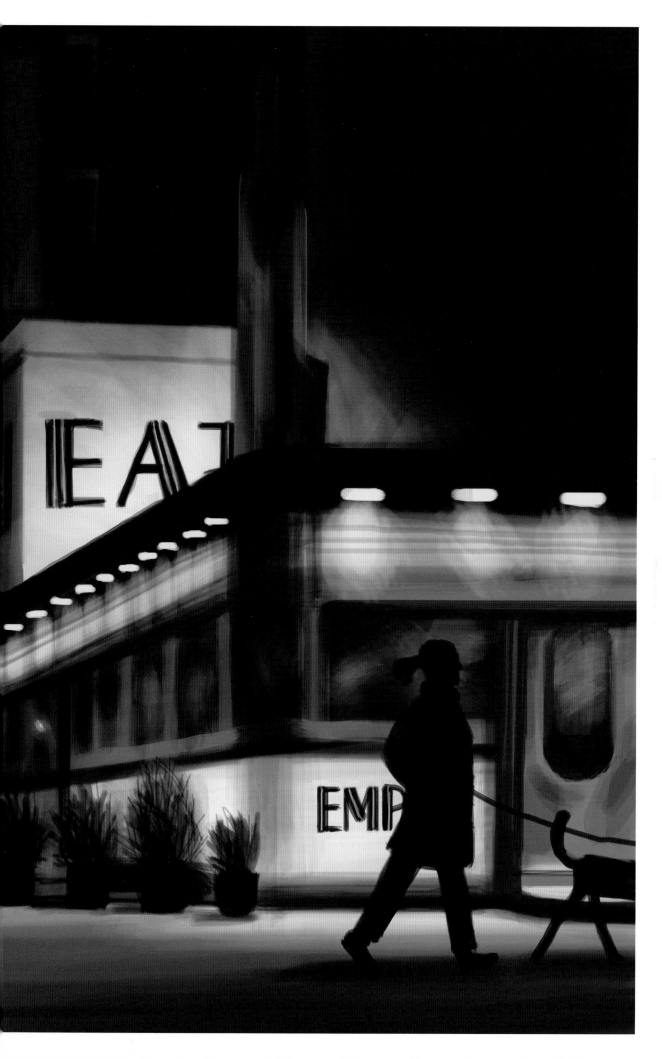

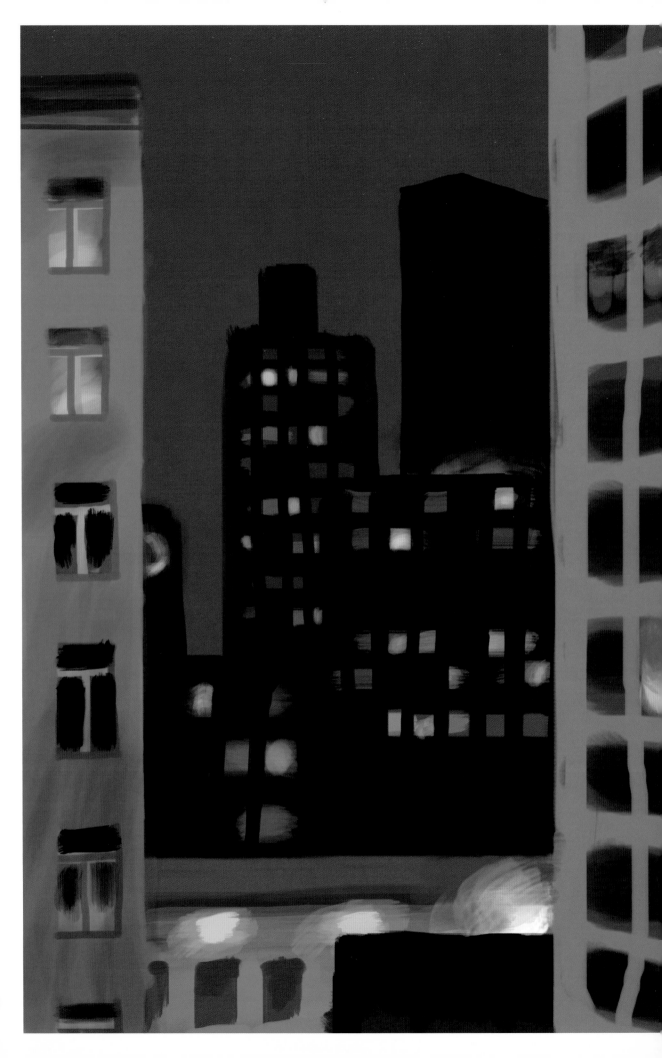

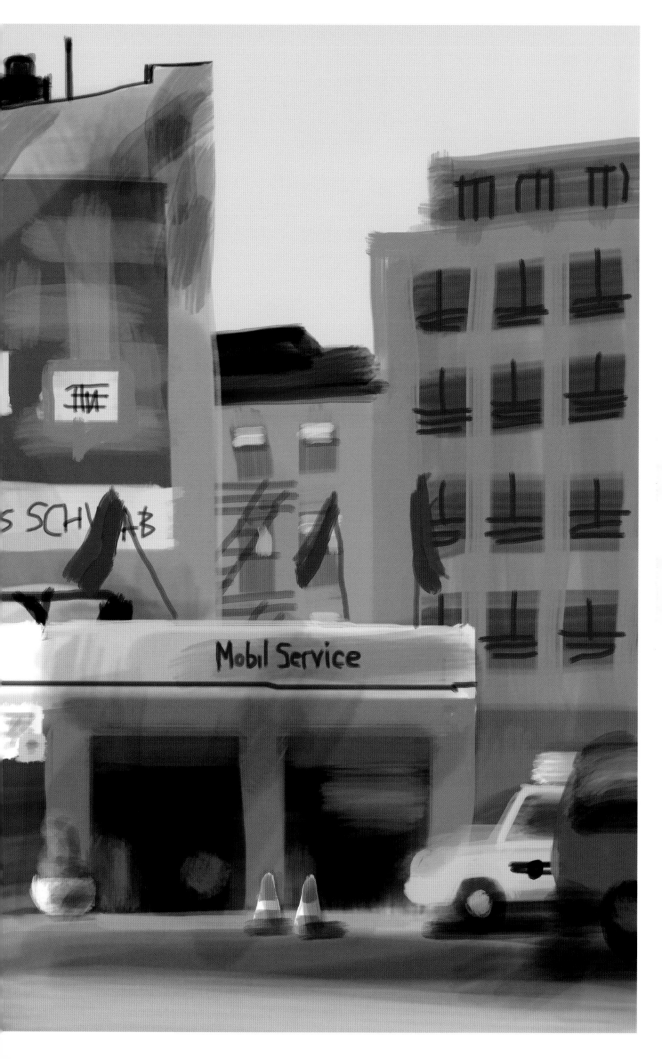

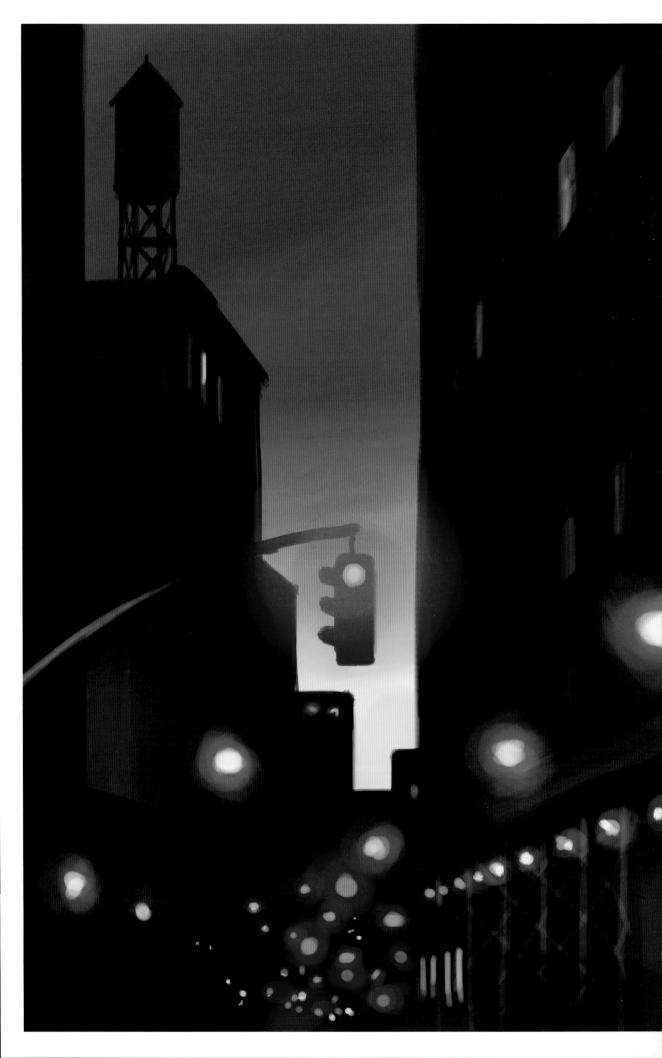

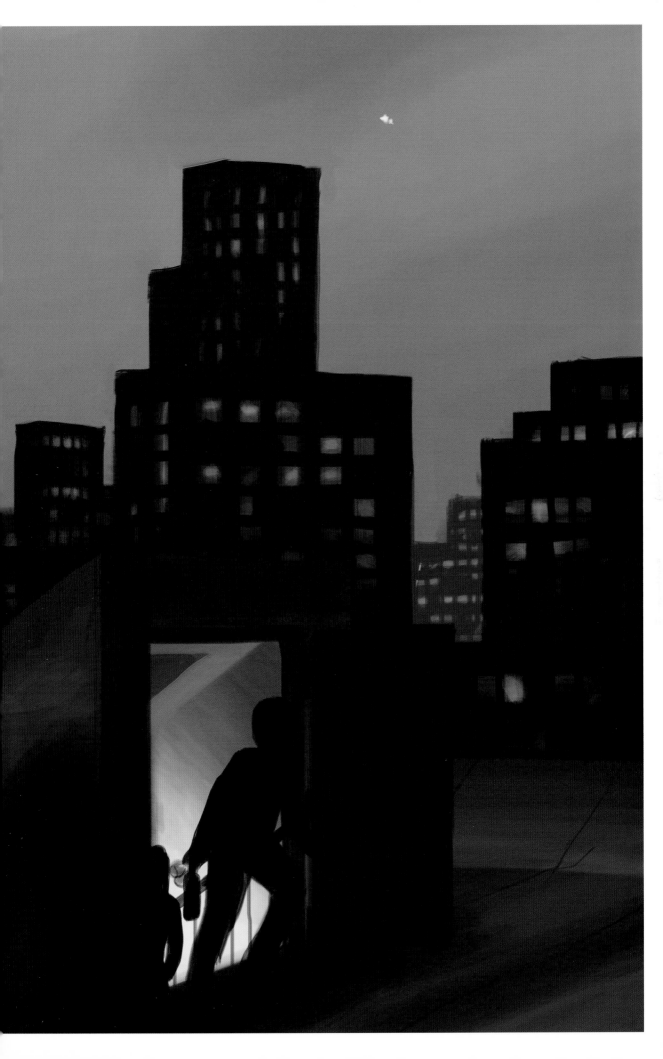

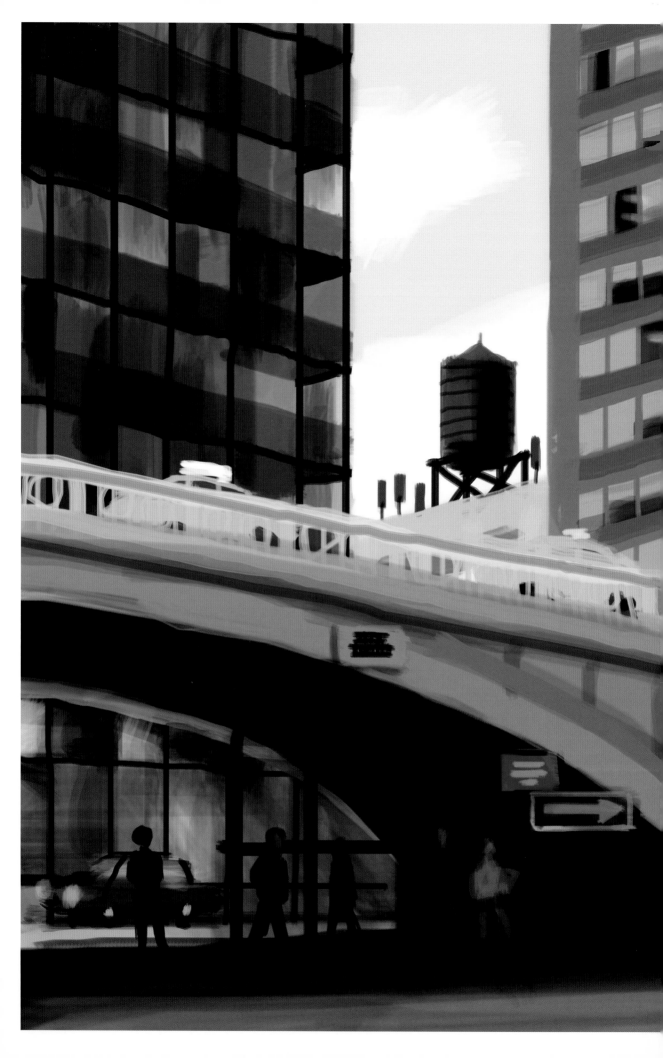

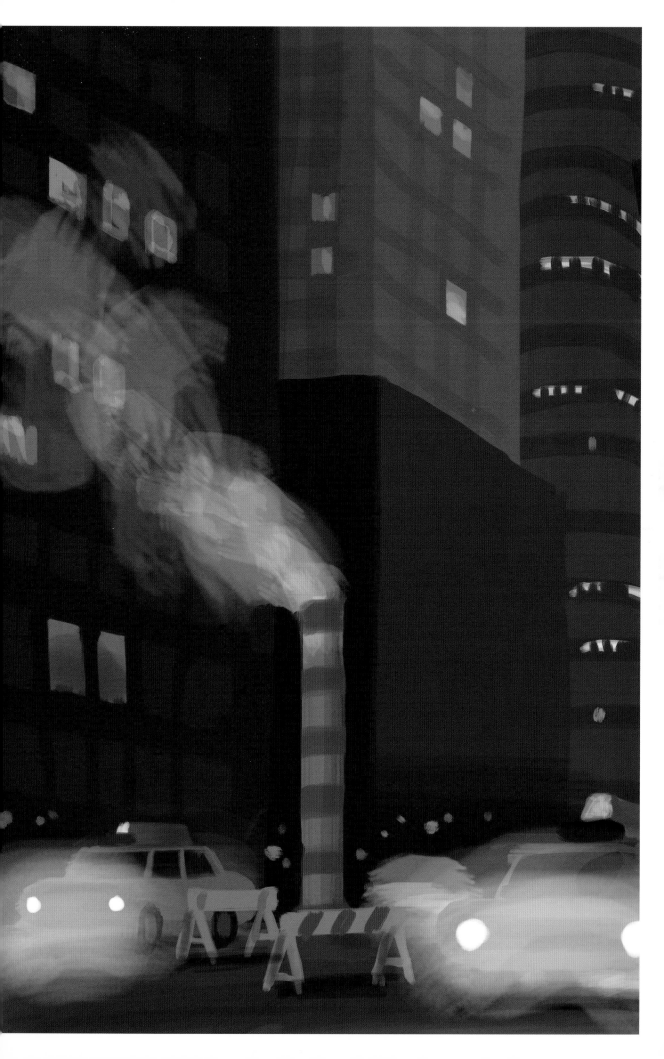

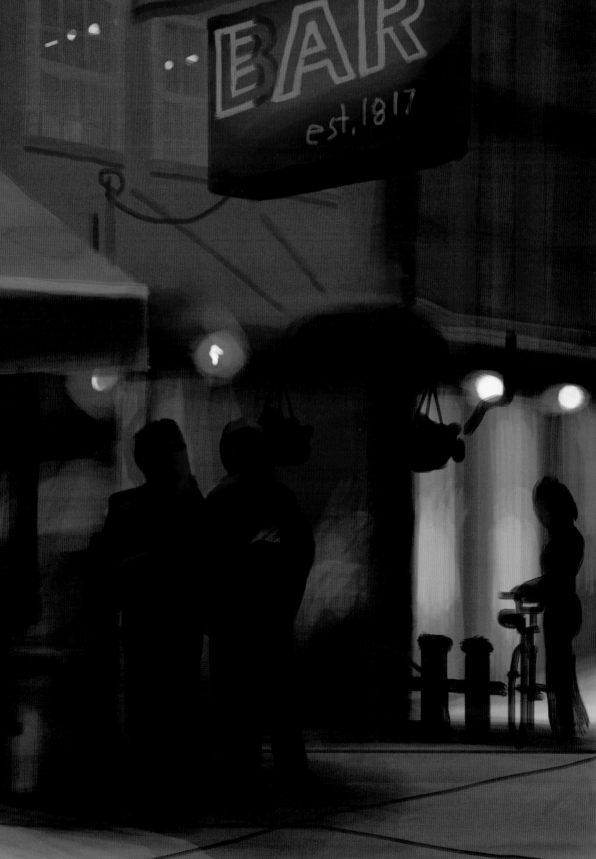

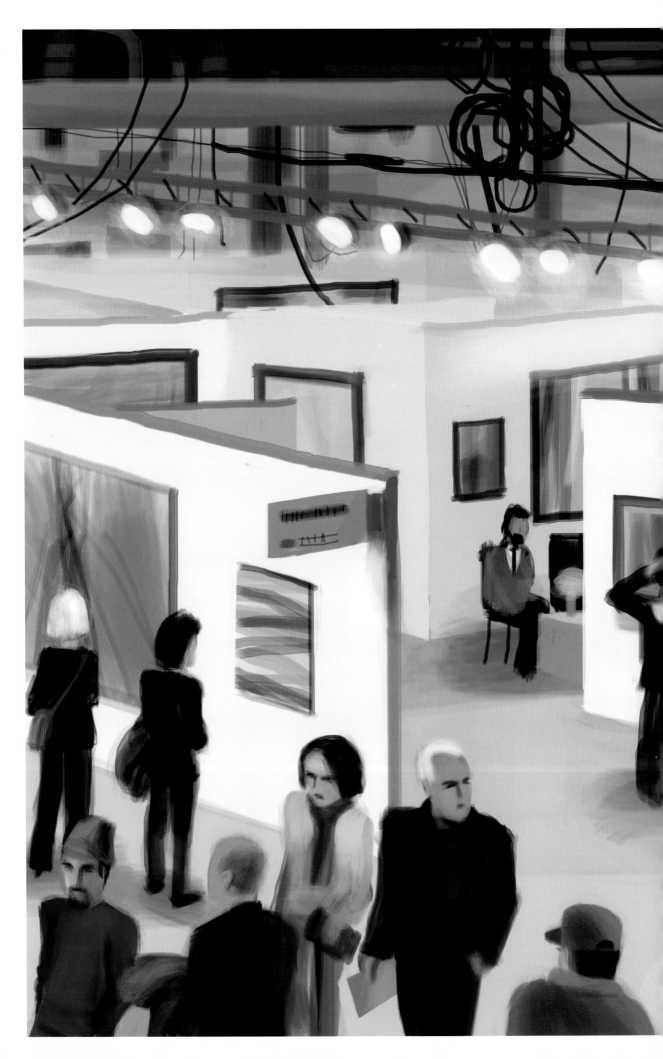

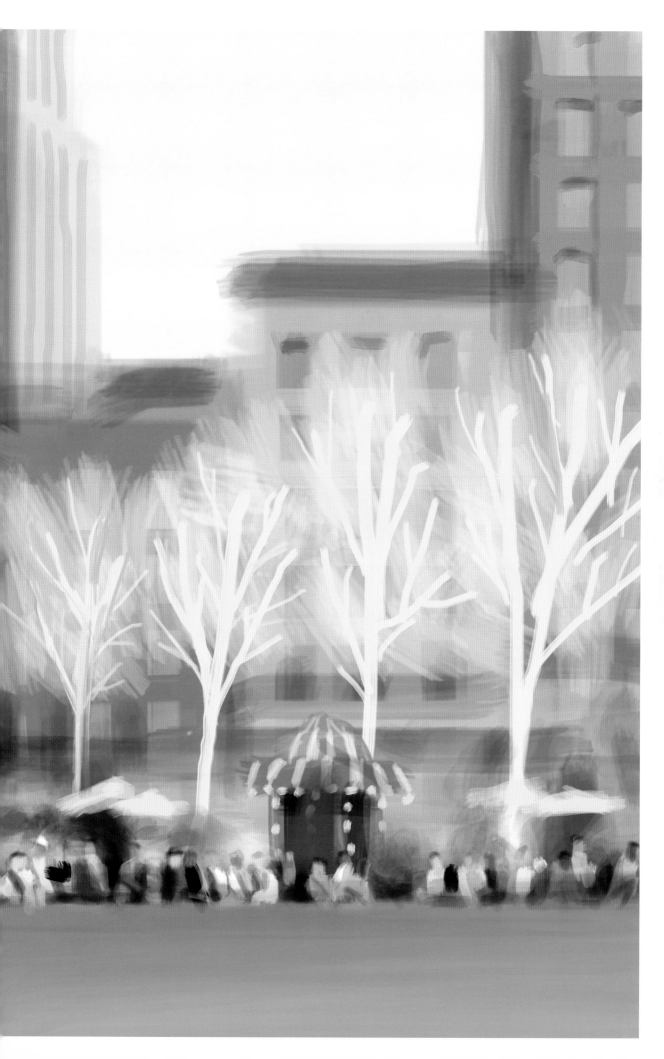

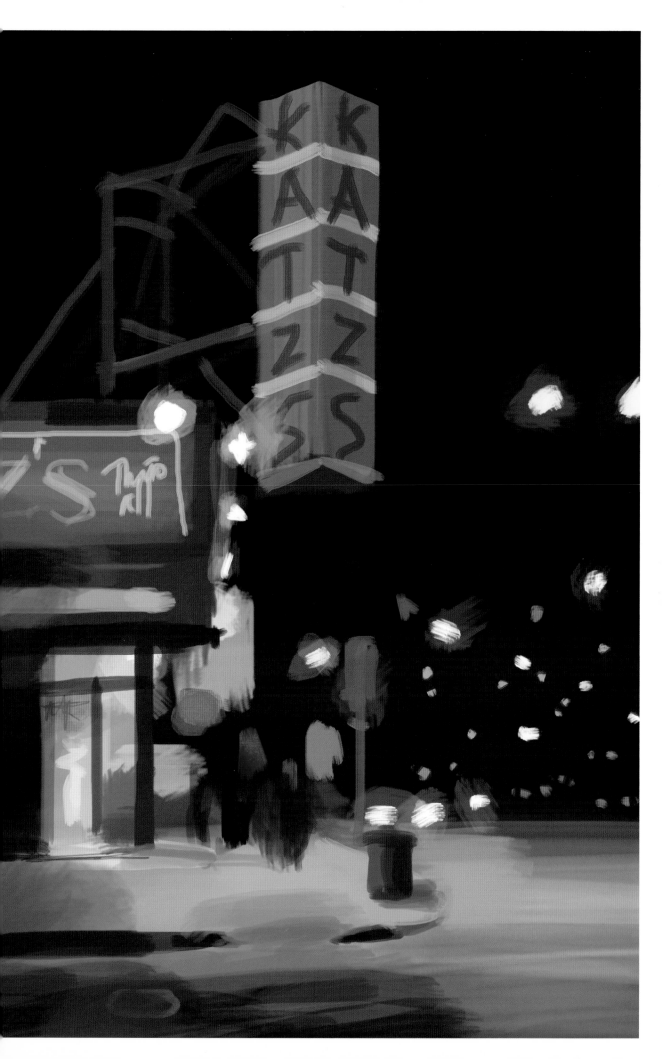

NOTES BY JORGE COLOMBO

All images finger-painted from life, on location, on an iPhone screen. The numbers in italics correspond to the serial number of each digital file. These are some personal comments on the intention or execution of each piece.

40TH STREET AND EIGHTH AVENUE

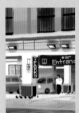

Buildings converted into parking lots feel more like buildings in disguise. Gutted into open floors with only an elevator connecting them, the buildings are like a graphic scheme for traffic—the bold colors, the big arrows, the instructions—as if a sketch done with markers on a notepad had come to life. *(0111)*

BROADWAY AND 72ND STREET

This is my favorite visual DNA strand of New York: a compressed mismatch of Deco, Victorian, and lowly utilitarian (the Sleepy's box perched over the strident Gray's Papaya), plus the hilariously dignified subway stations. You can count three different light fixture styles in the same image. I hope they never change. The beauty of a melting pot does not apply only to people. *(0606)*

LEXINGTON AND 53RD STREET

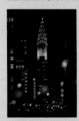

I used to come back home to be greeted in the dark by all those sleepy, blinking appliance lights that defined the cornerstones of my space: the camera recharging, the printer, the fax, the answering machine, the stereo, the alarm clock. . . . Then I stood on Lexington and tried to distill nothing but the

lights from the nocturnal landscape. It's one of the few drawings that I would definitely not have done were I not using a digital canvas. *(0324)*

PLYMOUTH AND WASHINGTON, BROOKLYN

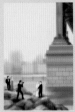

You can add or omit details in a painting and nobody will ever find out. Most of the images in this book are faithful depictions of a witnessed scene, down to the lighting conditions (something I used to change liberally back in the days when I worked in watercolor). Landscape elements may be glazed over or pushed forward, and proportions are often fudged, but the final results aren't that far from reality; and the characters depicted are for the most part people who stepped into the image while it was being made (even if they were altered or became a composite of several people). The things this particular drawing doesn't show are, for instance, that it was drizzling that day, causing the photographer to shelter his subjects under the Manhattan Bridge; that the bridesmaid and the best man were holding umbrellas; and that there was nobody else in the party to be photographed. It was a private, happy moment in the rain. But I'm sure the photographs looked great with Gotham on the horizon. *(0561)*

GRAND CENTRAL TERMINAL

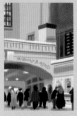

Grand Central is one of the most spectacular, theatrical settings in New York City. Unlike the people scurrying through the messy, contrived traffic patterns of the disastrous Penn Station, commuters in Grand Central's atrium are compelled to play their bit parts in

the travelers' ballet—be it the massive dance of rush hour or the solo sprint down the ramp of a late-night straggler catching the last train. *(0104)*

HOUSTON AND BROADWAY

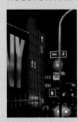

It's sad to think those huge letters—the D and the K and the N and the Y—that let you peek into an aerial vista of New York City are gone, painted over by a far less charismatic ad in brown tones and with insipid type. For a certain constituency, the intersection of Houston and Broadway is sort of crucial, a trigger for countless reminiscences. It was only fitting that its main ad was charismatic. (The other one, across the street, is usually a Calvin Klein spot whose ever-changing content is keenly judged by New Yorkers for its titillation level.) *(0140)*

TIMES SQUARE

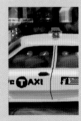

It's hard to keep a New York City taxicab in the same place for very long, so I just stood on a Times Square corner and painted a bit of each car that stopped at the red light. This must be a composite of about fifty taxis. They are not that different one from the other. *(0153)*

COLUMBUS CIRCLE

Each city's subway system has its own personality, some expressed in a more muted way than others. NYC's subways are currently in a decaying phase: virtually putrefactive under overwhelming budget cuts. They tend to come alive when they're undergoing repair or renovation. Their true

colors—an improvised mishmash of strong blue protection fences, urgent yellow union signs, caution tape, orange piping—comes to join the candy constellation of subway system symbols. *(1613)*

WILLIAMSBURG BRIDGE

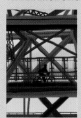

Speeding along the bicycle lanes on New York City's bridges, massive iron structures all around you, has Jules Verne undertones. The Brooklyn Bridge offers the most dramatic upward angles—the double ogives, the spider netting of iron cables—but the Williamsburg Bridge, with its eastbound/westbound pedestrian traffic segregation, is like a cavernous tunnel in the air. *(0577)*

125TH STREET AND RIVERSIDE DRIVE

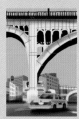

Around 125th Street, the underbelly of Riverside becomes a virtual cathedral. One wants to view contemporary elevated arteries with similar awe, but the splendor was lost with the decline of iron-based architecture. *(0186)*

METROPOLITAN MUSEUM

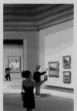

The architectural hodgepodge of the Met is tantalizing: everything is tended and refined, but no wing bears a relationship to the adjacent ones. It's like a scrapbook of museum rooms put together. Very fitting for New York City, and for an American museum, if you think about it. This was drawn in front of some Renoirs and, of course, nowadays people have an easy way of carrying their favorite paintings close to their hearts. *(1057)*

BROADWAY AND BLEECKER

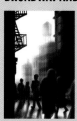

In the mid-afternoon, the blinding winter sunlight turns Broadway into even more of a black-and-white scene than it already is. In his *Cities* project, Raymond

Depardon photographed a series of locations around the world, each image bearing the city's most salient characteristics. And even though Depardon was, for once, using color film, his Paris series is as grayscale as one can get, short of using black-and-white film. In the early '80s, Depardon (a world traveler most known for his work about the African deserts) wandered the streets of NYC and sent a daily photograph coupled with his deeply personal reflections to the *Libération* newspaper in Paris. Those were all black and white, mostly passersby that seemed to elude the photographer. I think of this painting as a Depardon moment. *(1585)*

27TH STREET AND SEVENTH AVENUE

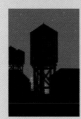

Snuck out of a birthday party to see if this Chelsea building had an easy access to the roof. It's never a given. The hardest part is to make it up there without disturbing the top floor neighbors. This one rooftop wasn't locked, but there was construction going on. I found myself tiptoeing around, Jacques Tati–style, trying not to topple scaffoldings, or to make a huge racket on the gravel. *(3216)*

WEST 125TH STREET

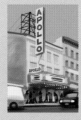

Central 125th Street has acquired a vaguely suburban atmosphere. Chain stores lend it a sort of 34th Street persona, minus the skyscraper context. Yet the Apollo Theater (whose Wednesday Amateur Nights still keep going strong) projects into us a glimpse of a Harlem perhaps not entirely gone. *(0185)*

BROADWAY AND 12TH STREET

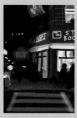

This is where it all started: the Strand Bookstore was the first New York landscape I tried to paint on the iPhone. Before moving here, I stopped at the Strand every time I visited New York. The store has lost some of its patina, but the labyrinthine layout and the

cavernous proportions remain compelling—and so do the discount prices. *(0076)*

178TH STREET AND FORT WASHINGTON

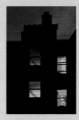

Hitchcock set the tone: backyard windows as a multiplex theater where every window tells a different tale. I was living in Washington Heights at the time, and from the kitchen window, I had a vantage point on someone's fridge raids. *(0244)*

178TH STREET AND FORT WASHINGTON

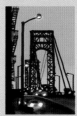

Living right next to the George Washington Bridge (in an apartment we called the Ramphouse) meant that the last steps on my way home always offered a classic snapshot of the bridge, be it fog, night, or sunset. (Hitchcock included a misty shot of it in *The Wrong Man*.) The bridge is great for strolling on (you're on the traffic "sidewalk," right above the water), even if there's little to do near the Jersey exit. During rush hour, you see countless people clearly marching to or from work. Can't think of a more monumental commute. *(0106)*

FIRST AVENUE AND 12TH STREET

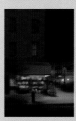

Let's for a moment look at a corner deli as a colorful jewel box brightening an otherwise somber block. Deli flowers are normally less than vivacious; but on a dark street, tended by a bundled-up guy on the graveyard shift, they are the most magical of explosions. *(0279)*

PENN STATION

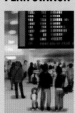

I find Penn Station hellish, unbelievably dysfunctional in the way it handles its traffic. If you already know your way, you're fine; but newcomers are invariably lost. However, I do like watching commuters staring at the oracle of the departure board until it flutters, revealing their platform number, with mere minutes to board. Then there's a stampede. *(0284)*

WEST 67TH AND COLUMBUS

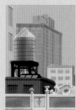

I'd love to slice off the rooftops of a lot of buildings such as these and lay them down side by side on the ground, like a complex maze of water towers and cornices and AC units and antennae and skylights and black tar and silver roofing—and sunning decks and trees, in more than a few cases. *(0257)*

CORTLANDT ALLEY AND WALKER

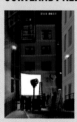

I found out the name of this production later, but I've forgotten it. Nothing to write home about, some minor TV show. A NYC street lit for a shooting crew is charismatic: façades and volumes reveal themselves in ways you'd never see otherwise, like people dolled up for a party. So, once again, a distortion of the street's actual lighting values is about to find its way onto a screen. But who cares: here's Cortlandt Alley ready for its movie-lit close-up. Too much time spent lighting "for film," too little spent capturing the real light of the streets. *(0160)*

DUMBO, BROOKLYN

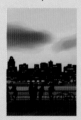

The park was busy that evening. Just off the frame of this view, a movie was being projected outdoors, and it took me a while to decide what to draw. I went with the skyline; the outdoor projection ended up in Adrian Tomine's wonderful cover for the August 24, 2009, issue of *The New Yorker*. *(0680)*

181ST STREET AND FORT WASHINGTON

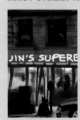

I'm not sure I've seen the word Superette used anywhere else. Jin's is the all-night resource in Washington Heights. The bubble-like contraptions convenience stores such as this assemble every winter around their entrance, sheltering fruit and flowers in an incongruously tepid temperature, remind me of decompression chambers for deep-sea divers. *(0100)*

PLATT AND WILLIAM

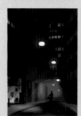

It's only a matter of time until the bicycle delivery-man carrying tinfoil and Styrofoam containers in an "I Heart NY" plastic bag will be a ghost from past eras, like the town crier or lamplighter. *(0346)*

GREENWICH AND VESEY

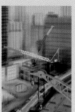

I wasn't around or even looking when the two towers fell. I got downtown later that 2001 afternoon, just in time to witness the collapse of 7 World Trade Center from not too far away. This image of the Ground Zero construction works was painted in the fall of 2009 from a window of the new 7 World Trade Center building, right where the previous one once stood. *(0779)*

SEVENTH AVENUE AND 33RD STREET

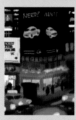

I spend most of my time at sidewalk level, so any change of perspective is welcome. Borders' Bookstore in the McGraw-Hill Building, right near Madison Square Garden, overlooks a particularly colorful corner of Seventh Avenue. *(0086)*

THIRD AVENUE AND 12TH STREET

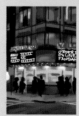

On each floor, a bunch of movie theaters; but it's from the sidewalk that you get the best urban moment, when the crowds descend the escalator en masse after each showing. This was one of my first New York landscapes, painted sometime in February 2009, and I remember discovering the discomforts of working outdoors for one hour with fingers exposed. *(0091)*

60TH STREET AND EAST END

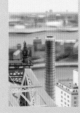

From the new, black high-rise above the Queensboro Bridge, the divisions between Manhattan, Long Island City, and the fortress-like Roosevelt Island become as schematic as those on

a scale model. From most towers, city zones merge into each other in a fuzzier way. Here, the demarcations drawn by the East River are perfectly clear. *(2558)*

HIGH STREET STATION, BROOKLYN

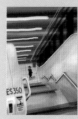

This is my home station at the moment, about six floors' worth of vertigo sprawling under Cadman Plaza, disorienting tourists looking for the Brooklyn Bridge entrance. The escalators on the side are not very fast; I find it easier to run up and down the stairs. *(1045)*

ANCHORAGE AND PLYMOUTH, BROOKLYN

In the '30s, photographer Berenice Abbott dragged her tripod around these streets. Dumbo is a multi-level labyrinth, two monumental bridges hovering above, and all sorts of access ramps creating a sort of steampunk science-fiction environment. There are more unique vantage points here than anywhere else in the city. Pretty lonely. *(0141)*

66TH STREET AND BROADWAY

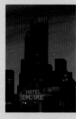

Not all buildings work as well as these do silhouetted against the city sky. I'm always on the lookout for the right crescendo of volumes, the epic accumulation of disparate shapes. In this case, Columbus Circle's Time Warner Center twin towers are a perfect culmination, turning a black mass of buildings into something mythical. *(2404)*

BROADWAY AND SPRING

As the snow melts, strange plastic huts sprout along the sidewalks, and counterfeit handbag transactions are played as a shadow theater to the entertainment of passersby. Is it my impression or does Broadway feel much more somber than it used to be? *(1536)*

58TH STREET AND EIGHTH AVENUE

The Time Warner Center on Columbus Circle feels like an odd Euro enclave at the corner of Central Park. The shopping mall inside feels strangely un-American, and both imported brands and Botero sculptures underline the feeling. But step outside, right by the subway entrance, and a familiar mess of sidewalk awnings, iffy cranes, and gaudy warning colors is there to bring you back. *(0472)*

MANHATTAN BRIDGE FROM THE BROOKLYN BRIDGE

Sometimes gray, sometimes brown, sometimes purple, the color of the sky above a city is an unpredictable aura, clouds mirroring every streetlight and open window and billboard and moving vehicle. *(2637)*

42ND STREET

Back when I lived in Chicago, I frequented many hot dog stands. There they fill up the bun with a lot of trimmings: onion, relish, sauerkraut, and so on. So, as an ex-Midwesterner I feel something lacking in the starkness of New York–style, or should I say Coney Island–style, hot dogs. But, considering that this painting made it onto the cover of *The New Yorker* as the first digital cover created in the very contained and restrained context of an iPhone, it makes sense that it depicts NYC's classic mini-restaurant on wheels. *(0446)*

FIFTH AVENUE AND 59TH STREET

My cover for the June 1, 2009, issue of *The New Yorker* (see previous page) got a reasonable exposure. Time to share another of the versions sent to Françoise Mouly (out of a total of four). This one was drawn on Fifth Avenue, outside a famous all-night tech establishment, with the Plaza in the background. After a certain hour all gastronomic bets are off, and no sight is more welcome than a smoky cart on the sidewalk. I remember showing Françoise videos I shot of some golden youths, tuxedo- and evening-gown-clad, jumping from an SUV and filling up on hot dogs before resuming their partying. *(0432)*

SPRING STREET STATION, 6 LINE

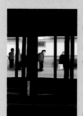

The catalogue cover for the 1999 retrospective of my drawings from the '90s, "Fullerton," showed this same station, but in watercolor. As it happens, I first looked up this particular station sometime in the mid-'90s after seeing a drawing Guy Billout had made of it—with one of his signature twists, of course. His studio was actually next door at the time. *(0207)*

SOUTH PARK AVENUE AND 28TH STREET

Vintage photographs of New York often leave me longing for an era when large typographic billboards were more prevalent. I love a cacophony of words hovering above passersby. Even if the designer in me snubs a few layout or typeface choices, I tend to prefer a word written loud to an image blown up. And parking lot signs, screaming hourly rates and earlybird specials on block corners, bring me closer to the urban voice of Walker Evans's NYC images. *(1939)*

CONEY ISLAND

I have been to Coney Island in the winter so often that I tend to forget it was conceived as a summery place. The Weegee crowds are iconic, but once void of humans the beach, boardwalk, and silent attractions turn into a sort of cold De Chirico. This painting was made specifically for the cover of a Brazilian literary magazine called *Serrote*. Painting on the beach in early February proved uncomfortable: the Atlantic wind froze my fingers, and I had to retreat behind some closed pavilions halfway through the drawing, restoring my circulation just enough to finish the image. *(1766)*

WEST 177TH STREET AND BROADWAY

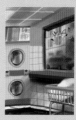

When you're lucky, your laundromat is silent and cool and almost empty, and the amenities—the tables, the magazines, the drinks, some heaven-sent wi-fi—make time go faster. Otherwise, you're trapped among kids jumping up and down on the folding tables. *(0154)*

VESEY AND WEST BROADWAY

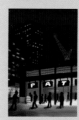

The Ground Zero PATH station, a temporary hub of suburban lines, feels very theatrical. There's something stage-like about the grandeur of its entrance, the ritualistic march of harried commuters, the bright contrast of lights against the empty sky, the hovering construction cranes. And, like so many stages, this structure may not last long, as the new towers progress and a more definitive station takes its place. *(0133)*

SMITH AND WEST 9TH STREET, BROOKLYN

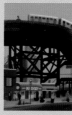

The F line flies over Carroll Gardens with a cyclical racket of clangs and shrieks, yet all I can think of is the majesty of the structure that holds the train in the air. It's an engineering schematic brought to a larger-than-life scale, as if ink had effortlessly turned into iron. I miss the days when structural achievements were so proudly and effortlessly displayed above the streets. *(0233)*

A LINE, MANHATTAN

The A line makes a complex connection between Manhattan and the JFK airport, so the odds of bumping into luggage are always a tad higher here than on other lines. Sneaking over someone's head or shoulder to consult the subway map is a minor urban etiquette conundrum. *(1225)*

METROPOLITAN MUSEUM

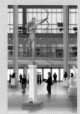

The American Wing of the Met landed with a timeless aura, as if it had been part of the museum forever. Its scale, its vertical expanse, its generous windows, make for an ever-changing variety of light conditions, as if someone were playing with a bank of light dimmers and theater lights. *(0595)*

CRANBERRY AND HENRY, BROOKLYN HEIGHTS

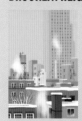

It took me years to get a bedroom window with water towers on the horizon. There's something frank, unabashedly utilitarian about sticking such a functional element above a building. Sometimes they get encased in some walled contraption, but that's a prudish move that reflects more poorly on the architecture than if the water tower had been left alone. *(1554)*

COLUMBUS AND WEST 67TH STREET

As chains proliferate—from suburban malls to this coffeehouse a stone's throw from Lincoln Center—I tend to concentrate on the private, quiet stories of people who end up sipping a grande or mooching the wi-fi. Regardless of the corporate branding and generally unified retail landscape, we're still witnessing private moments of reflection, of work, of intimacy, of bliss, of doom. Our sympathy for quaint vintage settings makes us wish chrome diners and non-chain cafeterias were still proliferating. But the Edward Hopper moments of today are taking place under the Starbucks logo. *(0116)*

HIGH LINE

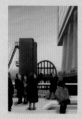

There is a lot to see on the High Line itself—the domesticated "wild" vegetation, the understated lighting, the constant flurry of sneaky fashion shoots—as well as around and beneath it. But near the Standard Hotel, famous for uninhibited patrons parading themselves before the wall-to-ceiling windows, the audience is more often than not gazing upward, not downward. *(1223)*

BEEKMAN AND PARK ROW

Street construction scaffolding and fences (this one drawn from a Starbucks right across the street from J&R) are timeless, aimless sculptures alternating drabness and brightness, clarity and vagueness, solidity and gauziness. *(0536)*

JOHNSON STREET, DOWNTOWN BROOKLYN

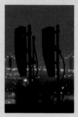

We still think of water towers as quintessential New York rooftop accessories, but one day we'll look up and they will all be gone. There will be more cell towers than ever, though: the new players in the organic evolution of urban landscape. Then a time will come when cell towers themselves will be nothing but decaying remainders of early century communications. And something else will be sprouting on rooftops. *(0946)*

QUEENS

The world is full of ground landscapes as glimpsed from an airplane's window seat. It's a modern kind of standard art exercise, like a vase of flowers or a reclining nude: everyone ends up painting this view at some point. *(1753)*

GREENE AND SPRING

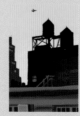

The title on this magazine cover (*New Morning*) is a bit misleading, because I drew this at sunset, but the gravitas of the water towers is as accurate as possible. I can't get onto a SoHo rooftop without thinking of Brian Eno's early '80s project. He used to prop up his now-obsolete video camera on the windowsill of his loft (sideways; he had no tripod, so he then had to turn his TV monitor on its side as well!) documenting placid changes in the light above Manhattan landscapes, like a painting being painted slowly before our eyes. He called the project Mistaken Memories of Medieval Manhattan. At points, he said, the water towers came across as primitive constructions from a much earlier era. *(0157)*

KENMARE AND LAFAYETTE

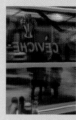

I drew this corner joint years ago when it was a much more nondescript, grimy taco joint, and didn't even have a Spanish name, if I recall it correctly. Now La Esquina—surrounded by even hipper spaces, to the sides and even underneath!—has become a magnet for late-night wanderers of the glitz. Truth be told, the fish tacos have become much better. *(1018)*

COOPER UNION

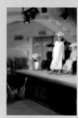

A snapshot from my niece's high-school graduation in the catacombs of Cooper Union. Graduations have their distinct personalities and, this being an arts-oriented school, there was a large presence of electric guitars on the premises. *(0570)*

FORT WASHINGTON AVENUE AND 180TH STREET

Many of these paintings try to convey New York–ness with a minimum of resources: sense of proportion, a certain kind of light, an archetypical architectural structure that will suffice. Here, a simple depiction of the city's urban furniture. *(0187)*

86TH STREET AND SECOND AVENUE

Seen from above, city rooftops and backyard allotments are an endless sequence of finite universes, repeating themselves with minute permutations, with

nothing by flimsy fences or tall enough walls to keep them apart. *(2398)*

42ND STREET AND FIFTH AVENUE

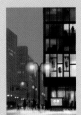

Drawing on location gets complicated when the weather gets too cold or, since I paint on an iPhone screen, when the sun gets too bright. Dodging adverse conditions, such as the post-snowstorm in this painting, becomes a game. I managed to paint this corner, diagonally across from the New York Public Library, by parking myself inside an ATM lobby. *(1942)*

STATEN ISLAND FERRY

Many of my New York paintings deal with the same basic question: how much can you take away and still retain the New York–ness of the vista under scrutiny? This was a foggy afternoon, and I took this ferry just to find out what was left of Manhattan to be seen. *(0510)*

CONOVER STREET, BROOKLYN

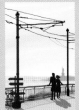

Red Hook is a remaining sleepy enclave of New York, and this image was painted from the outdoor tables at the Fairway supermarket. You're far, far away from the city here, even with yellow water taxis wheezing by on their commute to and from the nearby Ikea. *(2609)*

SEVENTH AVENUE AND 55TH STREET

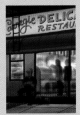

In the interest of full disclosure, let me note that a minor alteration has been made to the Carnegie Deli's façade proportions, with the purpose of better fitting the image into this 2:3 ratio. . . . But the lighting values, the hanging sausages, the innocent peppiness of the signage, even the relaxed busboy on his smoke break, everything is accurate. *(0957)*

BROADWAY AND 13TH STREET

I stopped going to movie theaters years ago— I watch movies all the time, but strictly with the privacy afforded by DVDs or streams—yet went back to the Union Square multiplex because I remembered fondly the quiet, church-like moments of shadow and anticipation in still-empty theaters, before the populace tramples in and popcorn hell ignites. *(0615)*

WEST 10TH STREET AND BROADWAY

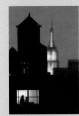

What we have here is a play on relative scales, the Empire State Building almost as small as the window where a mystery interaction is taking place, and both dwarfed by the monumental majesty of the looming water towers. *(0728)*

BROADWAY AND 66TH STREET

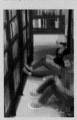

As I recall it, this young couple was reading and commenting on books about the acting technique (or was it the acting business?) hidden away on the floor of the Religion and Self Help section of the Lincoln Center Barnes & Noble. Floors at bookstores are as hot a commodity as restaurant prime seats, but without an arbitraging maître d.' For freeloading readers, the goal is discretion. Spots exposed to less sightlines are the first to go. *(0965)*

178TH STREET AND FORT WASHINGTON

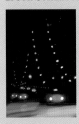

The endpapers of this book (those black and white pages right next to the cover) are part of another urban series called *Night Windows* (yes, from Hopper). The idea is to define volumes and perspectives merely by the arrangement of lights, or windows. We see no actual architectural shapes; we just re-create them in our mind as suggested by light points. This painting of the George Washington Bridge was an early instance of such approach. *(0386)*

57TH STREET AND PARK AVENUE

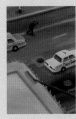

Bookstores are great places to hide from the rain and people-watch. They are a de facto alternative to libraries, cafés, and nap rooms: a relaxation facility disguised as a retail operation. I sat directly above a building's awning and kept observing the struggle for cabs in the drizzle. *(0746)*

BROADWAY AND 42ND STREET

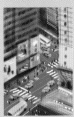

Any window over Times Square offers angles charismatic enough. This particular window has just as interesting a landscape indoors as outdoors: next to it is the wall where future *New Yorker* covers get lined up. It's thrilling to witness the sequence of images, many of them still in rough sketch form. But concentrating on the exterior landscape is exciting enough, especially if one tries to sort out all the visual components (the tiled-up billboards, the greenish window glass, the strident construction orange) that make this an early twenty-first-century streetscape. *(1012)*

FIFTH AVENUE AND 17TH STREET

Inflatable rats placed by unionists to protest labor practices at a specific business are a constant on New York sidewalks. I hear they all come from the same supplier. After a few too many pickets, rodents start showing wear and tear. You end up worrying about their health, like you would about someone showing up now and then with a few extra unsightly patches. *(0503)*

C LINE, SOUTHBOUND

I admit it, I don't get as irritated as I should if I'm forced to wait forever for a subway at 2 AM, especially if there's a cameo appearance by one of the MTA's late-night work crews. The patina on the sturdy outfits, the tools, the jarring colors of

the safety accessories, the dangling lights carried in a quasi-mystical fashion, everything is entertaining enough to help time go by. *(2397)*

43RD STREET AND MADISON

A TV crew had been following me that afternoon to shoot a small segment on my work. Which, of course, consists mostly of endless schlepping, looking for the proper vistas to stand around and draw. By the end of the evening everyone was exhausted. It was my turn to paint them dragging their gear. They traveled light. *(2422)*

LUDLOW AND STANTON

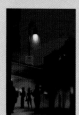

This was meant to be a classic Lower East Side sight: the bustling crowd on the sidewalk during the break of some show at Piano's. Everyone phones and texts and surfs as if a more real, more exciting moment is taking place anywhere but here. (Or out of pity to those who are missing out on the action.) *(0384)*

PARK AVENUE AND 125TH STREET

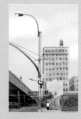

That building looked familiar; then I realized I had seen it doubling for a location in Chicago, in a B-movie with Tommy Lee Jones that involved a daring jump onto an elevated train. In the summer, Harlem is hot and bright, and it's not easy to paint on a screen unless you find the right shadow. I could have hidden under the train tracks, but there wouldn't have been much horizon to look at then. *(0737)*

SUTTON AND RIVERVIEW

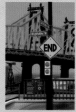

On my way to this location I Googled and downloaded the poster still from *Manhattan*, Keaton and Allen watching the sunrise from a bench that is no longer there. My light was wrong, my format was off—Gordon Willis was absolutely correct in shooting the movie in the most possessive widescreen ever. Still, because I saw *Manhattan* many years before I ever visited Manhattan, my notions of the city were shaped in no small way by those grayscale images. And of such memories are these pilgrimages made. *(0243)*

FDR DRIVE AND 135TH STREET

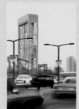

We had a flat tire on FDR and no tire jack to be found. This was a good way to spend time while waiting for the AAA truck, on the east edge of Harlem. *(0505)*

MONTAGUE TERRACE AND REMSEN, BROOKLYN HEIGHTS

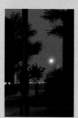

I don't do this that often, but I painted this to go with Scott Walker's 1967 song "Montague Terrace (in Blue)." Montague Terrace, a tiny segment of Brooklyn Heights, connects Remsen with Montague, almost overlooking the East River. A very quiet street, very fit for the dramas of the narrator's neighbors. Then I found out the Walker song is about another street in London, longtime torn down. *(1003)*

BROADWAY AND 112TH STREET

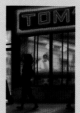

Tom's Restaurant used to appear often on TV (only the "Restaurant" half of the sign). I had first heard of it, though, through that Suzanne Vega a capella song that spawned countless remixes. The red and pink neons of the sign are so blinding, I totally forgot the background is really blue, not black. Doesn't look like it in the nighttime. *(0717)*

UNIVERSITY PLACE AND 9TH STREET

Everything about these paintings betrays my enjoyment for being able to say as much as I want with a minimum of resources. It was harder for me in the line-and-watercolor days. This is like playing a very loud instrument: enough impact as is, even without an orchestra. *(2497)*

LAFAYETTE AND GREAT JONES

The Village Voice, my alma mater of my early NYC days, is immediately beyond these buildings, and I spent a lot of time in this neighborhood during my first years in New York. In fact, this painting was done from outside what was once Fez, where I used to go to see so many artists I liked; and down the road the Tower Records emporium was a sure late-night stop, until it degenerated and dwindled away. But the triple-decker parking lots remain, like peeled-off cargo ships stranded in NoHo. *(0358)*

A TRAIN, NORTHBOUND

At rush hour there are too many characters in a train calling for your attention. But if you concentrate on the reduced cast glimpsed through the window of the door between the cars, you're watching a small play acted entirely by body language, the words of the commuters buried by the screeching of the rails. *(2525)*

BROADWAY AND 176TH STREET

I constantly look for faded ads on the sides of tall brick buildings. Before they started relying so much more on images, people used to write words in enormous letters on the American urban landscape. Now they're conscripted to pizza joints. I miss big words. Cities are loud; why shouldn't words scream as loud as everything and everyone else? *(0101)*

FIRST AVENUE AND 10TH STREET

Backstage at a theater is a world of darkness where every spot of light has a specific function and the lightbulbs over the mirrors are an anticipation of the spotlights that soon will be turned on. I had done digital sets for an off-Broadway ballet, and these were some of the dancers before the performance. *(1567)*

BROADWAY AND WALKER

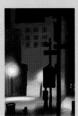

As buildings go down and temporary parking lots stand in their place—for years sometimes—we're given a chance to peek into building angles never meant to be seen. Why are there windows on only the top floors of the adjacent building? Quite likely because the vanished one once reached to just below them. *(0197)*

37TH STREET AND EIGHTH AVENUE

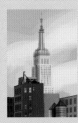

This painting was made from a rooftop in the Garment District, not far from Penn Station. I had been visiting the 19th-floor studio of a French artist with a large body of work painted or shot (or both) on that very rooftop, so as I snuck up the stairs for my usual attempt at checking out the vistas, I felt like I was poaching someone else's source material. *(0222)*

LASALLE AND BROADWAY

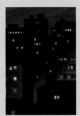

This view is painted from an apartment up in West Harlem. Painting a city nocturne is like charting a constellation or transcribing a melody. It's all about lights, about notes; a few dissonant sounds can throw off the balance of the piece. You start with every window in place, and then you turn them off one after another until you reach a decent pattern of mute and bright, of glow and glare, of openness and mystery. *(2469)*

13TH STREET AND FIFTH AVENUE

More than front façades, it's the backs of American buildings from the early part of the twentieth century that really interest me. I like their matter-of-fact accumulation of functional elements, like some sort of work rig or military vehicle. Not much of an effort is put into concealing pure functionality or beautifying the whole. *(1834)*

FIRST AVENUE AND 14TH STREET

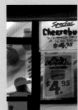

Entire books could be publishing about hot-dog joint signage. Operating within a spare set of parameters—black and the primaries; push forward the dollar amount; do not editorialize—they manage to push every single item, be it the gyro, the two-frankfurter deal, the Philly cheesesteak, a tantalizing contender on its own. But the lingering aroma of burning oil brings us back to reality, even under the distraction of gigantic paper strawberries. *(0208)*

BROOKLYN HEIGHTS PROMENADE

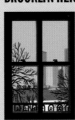

It's an old dilemma: is it richer to be inside the action or to sit in the audience? Downtown Manhattan has a hard-to-beat intensity and pedigree, but it's from any townhouse over the Brooklyn Heights promenade that the city truly resembles the theater set it was meant to be. *(1457)*

MADISON AVENUE AND 75TH STREET

Many of my New York paintings play with the unmistakable New York–ness to be found in nondescript vistas. Others concentrate on one-of-a-kind spots, such as this window, which museum-goers will recognize as being on the top floor of the Whitney Museum's northern façade. *(2401)*

TENTH AVENUE AND 22ND STREET

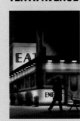

Vintage diners like the Empire are a bit too anachronistic for me. Sure, they're relics to preserve, but they hold too much nostalgia to continue to function as icons of banal, pedestrian, all-American basic food. They're period snapshots, like early Tom Waits. For as many misgivings as we may have about it, the contemporary equivalent of diners may be joints like Panera or Au Bon Pain or Chipotle. We have long since entered the chain era, and there's little to do about it. This drawing made it quite quickly to the cover of *The New Yorker*, and I suspect it had to do with it being an almost-black-and-white piece. The magazine has always had a thing for color restraint. As for the Empire, which had inspired countless pieces of art before my own contribution, it closed a few months after its cover moment. *(1867)*

LAFAYETTE AND HESTER

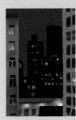

I had been participating in a video project and, sure enough, as soon as I left the studio I went up the stairs instead of down. There's always hope that, instead of the aggravating "Alarm Will Sound" sign, you will find the rooftop door open, and the view—as in the case of this Chinatown glimpse—will be worth painting. *(0098)*

HOUSTON AND PITT

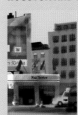

A couple of journalists were trying to document my working methods. We walked all around the Lower East Side; by the time I finally settled on this location, an hour had gone by. *(0488)*

PRINCE AND LAFAYETTE

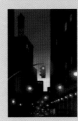

It's commonplace to refer to Manhattan's East-West streets as canyons. But during the crucial moments when the sun is about to set beyond the Hudson, and every building, tower, and scaffold becomes a brushstroke outlining a burning sky in jagged black shapes, what other epic term can we find? *(2433)*

13TH STREET AND FIRST AVENUE

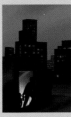

For a New Yorker, there are basically two kinds of rooftops: the ones you can go up to and the ones you can't. Rooftops like this one in the East Village tend to be blocked by the discouraging "Alarm Will Sound" lock, so they become

particularly appealing when a negligent super leaves the door ajar. They lack amenities, but the city night does a good job of turning the silver tar into a magic ground. *(2559)*

PARK AVENUE AND 41ST STREET

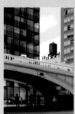

Just south of Grand Central Terminal's main entrance is one of those vertical bisections that make the city into a multilevel stage. The ensemble cast of textures is characteristic of New York, its growth spurts duly represented in each element. It's as New York as it gets: the tinted see-through structure, the massive bricked block in the background, the mandatory water tower . . . and the titanic iron ramp of the Park Avenue Viaduct, like a launch pad. *(2502)*

THIRD AVENUE AND 48TH STREET

I once spent a few days collecting video footage of Manhattan caught smoking through its ubiquitous street vents. I called the finished piece *Street Cigars*. No still image can do justice to the complex clouds hovering over the traffic, but the striped chimneys are majestic in any medium. *(0147)*

WILLIAM AND LIBERTY

Painting night windows is quite a pleasurable task with a loose medium like the one I use. It's all about spots of light casually laid against a black background, lines of spots suggesting shapes of buildings, perspectives reduced to their most basic indicators . . . and the crossword puzzle–like grid of lit windows and dark ones. *(2638)*

SPRING AND GREENWICH

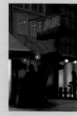

I think I discovered the Ear Inn in the early '90s via Ben Katchor, who took me there the first time I met him. Every-thing—the cramped interior, the hectic

furnishings, the pool of red light out-doors, the slightly out-of-the-way loca-tion—makes it a standard, a classic. Which makes sense for one of the oldest bars in Manhattan. *(0973)*

WEST SIDE HIGHWAY AT 51ST STREET

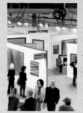

I prefer to watch the Armory Show from one of the lounges above the main room and to follow the wandering patterns of the crowds. Pier 92 becomes a maze, and everyone can be sorted as a specific species of art mouse. *(1984)*

2ND STREET AND SIXTH AVENUE

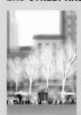

Bryant Park offers a precious city block of lawn at the very center of the action, a stone's throw from Times Square. The grass is the object of complex maintenance protocols, and often it gets cordoned off so that it can recover from outdoor film sessions. Then the crowds pile up in the margins, as if around a bright green lake. *(2399)*

PRINCE AND MERCER

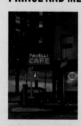

Fanelli's could have been created by a movie crew intent on devising the most charismatic, old-time SoHo hangout. The early version of this painting, as posted on *The New Yorker*'s blog, sports an embarrassing perspective mistake, which I finally corrected for the 20x200.com print edition. *(0263)*

HOUSTON AND LUDLOW

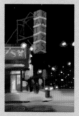

This was my second New York landscape for this series, and there will never be another one like it. I was far from mastering the medium: finger painting on a 3" x 2" screen was still a brand-new adventure. With time, I have acquired better methods and developed more confident nuances. Yet all that was to come is here already. And what a place

to start! Katz's is one of my favorite rel-ics in New York. I invariably bring first-time, foreign visitors here. The cuisine is not the most compelling attraction: the heavyweight pastrami sandwiches are an acquired taste, the egg creams a mere curio. You can find excellent con-temporary restaurants any evening and anywhere in the world; but Katz's is the closest you can get to a workman's everyday meal in 1940s New York. *(0084)*

RIVERSIDE DRIVE AND 139TH STREET

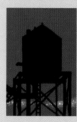

Everyone said goodbye and went to bed. I stayed on this rooftop a couple of hours, painting the water tower, painting the surround-ing blocks, taking photos of the traffic on the Hudson Parkway. It was hard to see where I was stepping; I moved carefully, under the spaceship-like presence of the huge tank. A few windows still lit across the courtyard, but silence throughout, that silence one can so often find, against all odds, in New York City. The kind of silence you could hear atop a mountain. *(2680)*

Jorge Colombo was born in 1963 in Lisbon, Portugal; he moved to the United States in 1989. He has lived in Chicago, San Francisco, and, since 1998, in New York City with his wife, artist Amy Yoes. He has worked as an illustrator, as a photographer, and as a graphic designer.

Jen Bekman is an art dealer, curator, writer, and entrepreneur. Her projects include her eponymous Manhattan gallery, the curated limited-edition fine-art print website 20x200.com, and the international photography competition *Hey Hotshot!*

Christoph Niemann is an illustrator, graphic designer, and author of several books. He writes and illustrates the *New York Times* blog Abstract Sunday.

www.jorgecolombo.com
www.20x200.com/aaa/jorge-colombo/
www.newyorker.com/online/blogs/
 fingerpainting/

Most paintings in this book have appeared originally in *The New Yorker*'s website in a step-by-step animation form, in the weekly section *Finger Paintings*. The paintings on pages 4, 45, 61, 66, and 97 were originally published as covers for *The New Yorker*. The paintings on pages 7, 9, 10, 14, 60, 98, 108, and 109, were originally issued as limited edition prints by www.20x200.com, a Jen Bekman Project. The painting on page 49 was created for the cover of the Brazilian magazine *Serrote*. The painting on page 31 was used as the poster image for the 2010 Gotham Independent Film Awards. The oldest image dates from February 21, 2009.

The author wishes to thank Jen Bekman, Daniel Blaufuks, Blake Eskin, Jake Gardner, Jessica Helfand, Emily Kan, Françoise Mouly, Daniel Murtagh, Christoph Niemann, Bridget Watson Payne, David Remnick, Matt Robinson, Leigh Stein, Matinas Suzuki, Claire Weisz, Amy Yoes, Mark Yoes, Mona Yoes, and everyone at Jen Bekman Gallery and at 20x200.com, especially Sara Distin, Kika Gilbert, Raul Gutierrez, Jonathan Melber, Youngna Park, and Jeffrey Teuton.

Also, for their logistical collaboration in facilitating some choice painting points of view: Suzanne Bocanegra, Nancee Oku Bright, Kristin Cammermeyer, Orly Cogan, CharlElie, Stephen Earle, Sarah Garcea, Mitchell Gross, Athena Kokoronis, David Lang, Henrik Langsdorf, Ruth Marten, Thomas McKean, Claude Ruiz Picasso, Kimberly Schamber, Jane South, and Sylvie Vauthier.

For my aunt, Teresa Colombo.

Illustrations © 2011 by Jorge Colombo
"Field Work" © Jorge Colombo
"Invisible City" © Christoph Niemann
"Home Turf" © Jen Bekman
Author photo (p.18) © Daniel Blaufuks

Library of Congress Cataloging-in-Publication Data is available.

ISBN: 978-0-8118-7925-5

Manufactured in China

Designed by Jorge Colombo

10 9 8 7 6 5 4 3 2 1

Chronicle Books LLC
680 Second Street
San Francisco, California 94107
www.chroniclebooks.com

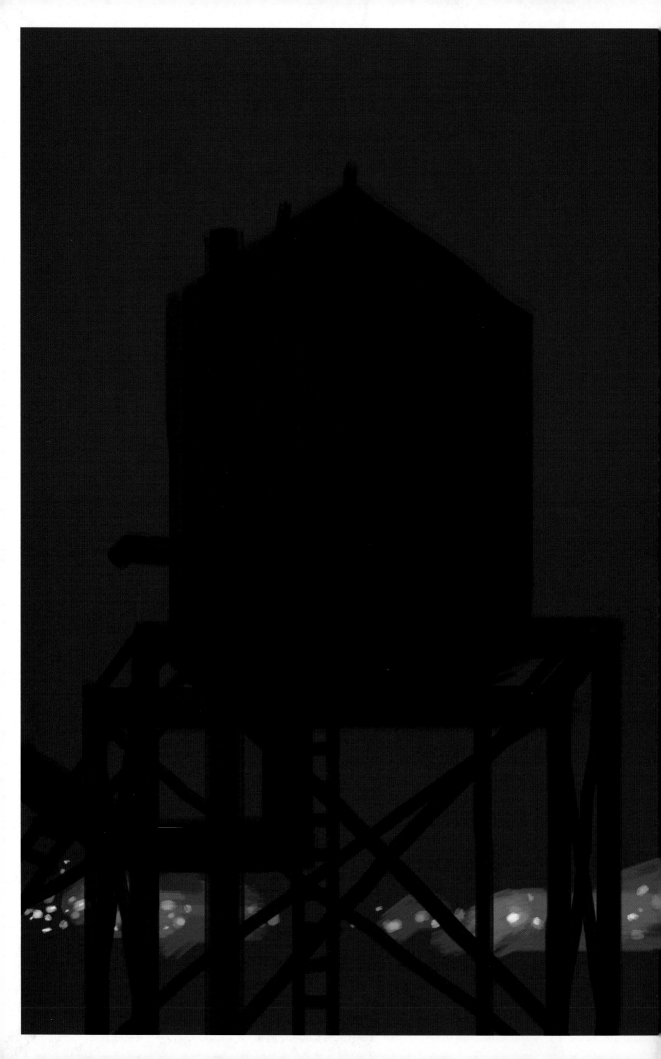

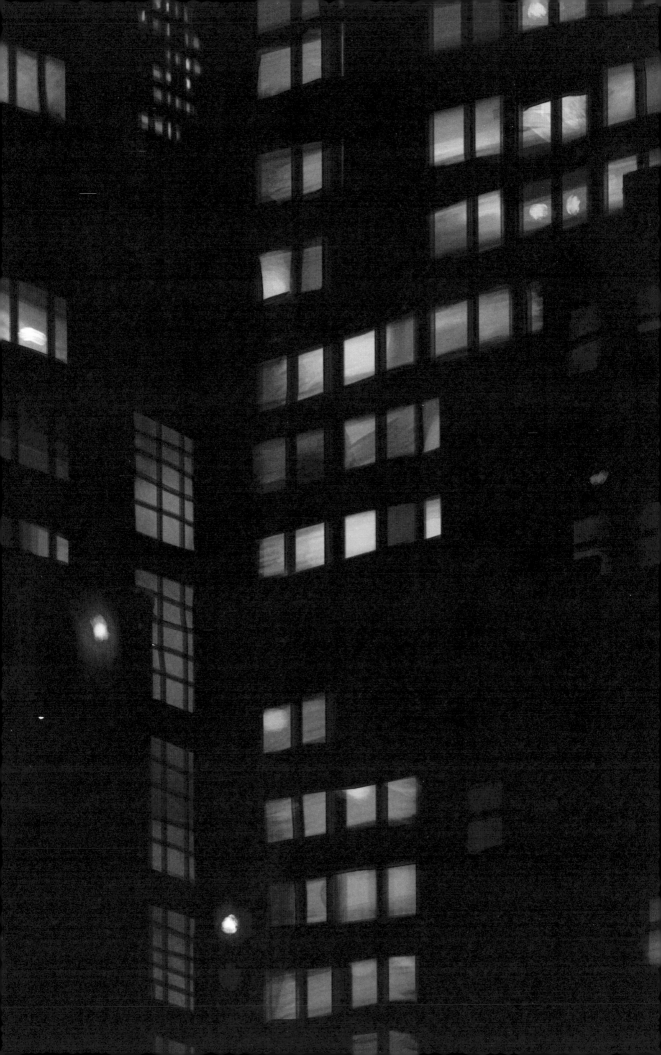